They praise you here as one whose lore, already
Divulged, eclipses all the past can show,
But whose achievements, marvellous as they be,
Are faint anticipations of a glory about to be revealed.

From *Paracelsus*, a poem by Robert Browning

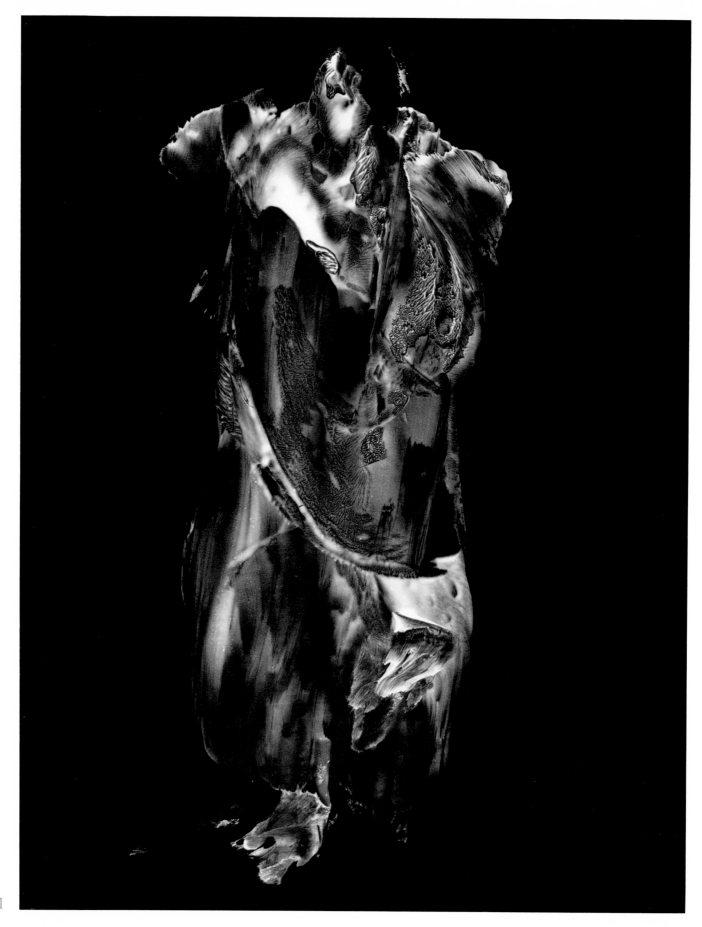

1

Prologue

It is no surprise that Frederick Sommer would be fascinated by Philippus Aureolus Theophrastus Bombast von Hohenheim, aka Paracelsus, the Great. Sommer's robust curiosity would surely propel him toward an encounter with this cognate spirit, this Bombast.

To state only that Paracelsus was a sixteenth-century Swiss physician is akin to saying that daVinci was an Italian scientist. For Paracelsus inspired fundamental changes in the structure of medicine that remain profound today. In a time when doctors prescribed cures from long obsolete texts and sent surrogates to attend their patients, Paracelsus demanded diagnosis and direct treatment by the physician. He was also the first to identify industrial disease and to insist on regulation of drugs.

If Paracelsus attracted passionate followers to his astonishing ideas, his attacks on an antiquated, indolent system incited equally ardent enemies. He repeatedly assaulted the opposition. He hurled their outdated medical books into bonfires. He mocked them, sneering at one, 'Thou shall be a fable without a head, a trunk and a useless piece of wood.'

These medicine men found a dangerous and savage foe in Paracelsus. His rivals soon organized, coercing him to abandon a prestigious appointment as City Physician of Basel. Paracelsus was exiled, living out his life on the road, wandering across Europe from village to village in the company of vagabonds and gypsies.

J. W.

Paracelsus, 1959

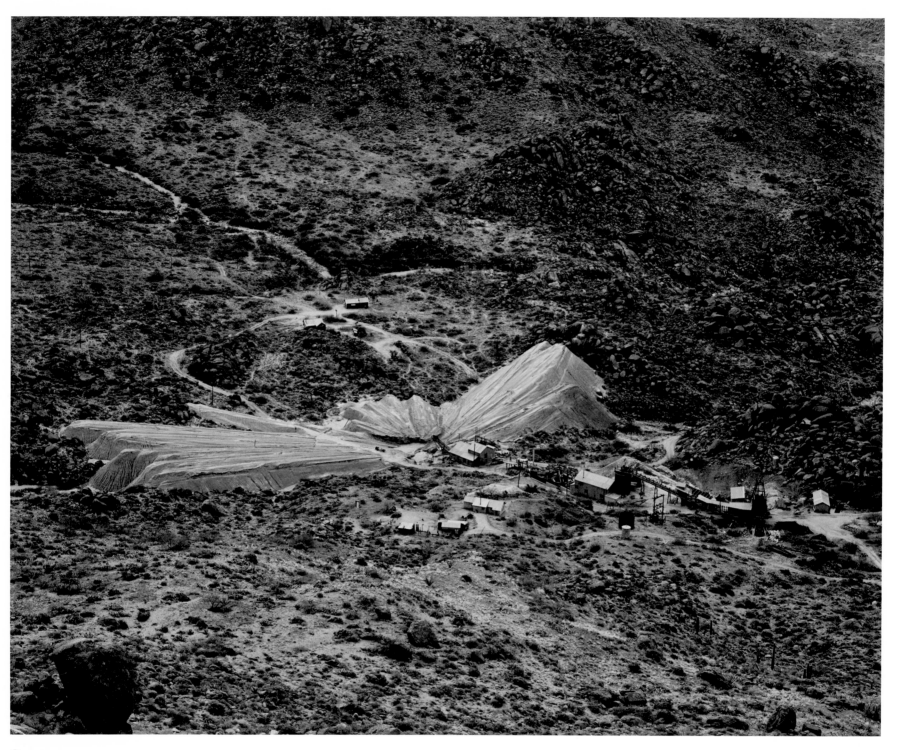

2

Venus, Jupiter & Mars

The Photographs of Frederick Sommer

Edited by John Weiss

An exhibition at the Delaware Art Museum from April 27 through June 8, 1980
Cosponsored by the Department of Art, University of Delaware, and the Delaware Art Museum

For Sara, the orchard of my eye

VENUS, JUPITER & MARS — *The Photographs of Frederick Sommer* has been generously supported by financing from the Ford Motor Company Fund; Container Corporation of America; the Delaware Art Museum; the Department of Art, University of Delaware; Light Gallery, New York; Mr. Aldo Romagnoli, proprietor of the Newark Camera Shop, Newark, Delaware; by two grant awards from the Delaware State Arts Council, a state agency, and the National Endowment for the Arts, a federal agency; and by several anonymous donations.

Library of Congress Catalogue Card Number: 79-930-53

ISBN 0-936594-00-4

FRONT COVER: *Venus, Jupiter & Mars*, 1949

BACK COVER: *Fred and Frances Sommer, Arlington, Massachusetts*
Lauren Shaw, 1973

Lenders to the Exhibition

Special thanks to our lenders, named and anonymous:

The Arizona Bank Collection, Phoenix, Arizona
The Art Museum, Princeton University
Dr. and Mrs. Grover Austin
David P. Becker
Peter C. Bunnell
Lucinda W. Bunnen
The Crocker Art Museum, Sacramento, California
Evelyn and Francis Coutellier
The Dayton Art Institute
Fogg Art Museum, Harvard University
Robert Freidus Gallery, New York City
Dr. and Mrs. Gene Gary Gruver
Susan Harder
Marc and Diana Harrison
Indiana University Art Museum
International Museum of Photography at George Eastman House
Krannert Art Museum, University of Illinois at Urbana—Champaign
Dr. Samuel H. Lerner
Light Gallery, New York City
Museum of Art, Rhode Island School of Design
Museum of Fine Arts, St. Petersburg, Florida
Museum of Modern Art, New York City
Gerald Nordland
Ingrid and Charles Semonsky
Sheldon Memorial Art Gallery, The University of Nebraska—Lincoln
Sun Valley Center for the Arts and Humanities, Sun Valley, Idaho
University Art Museum, The University of New Mexico
The Minor White Archive, Princeton University
Mr. and Mrs. Stephen White
Jonathan Williams
Mr. and Mrs. Emerson Woelffer

Table of Contents

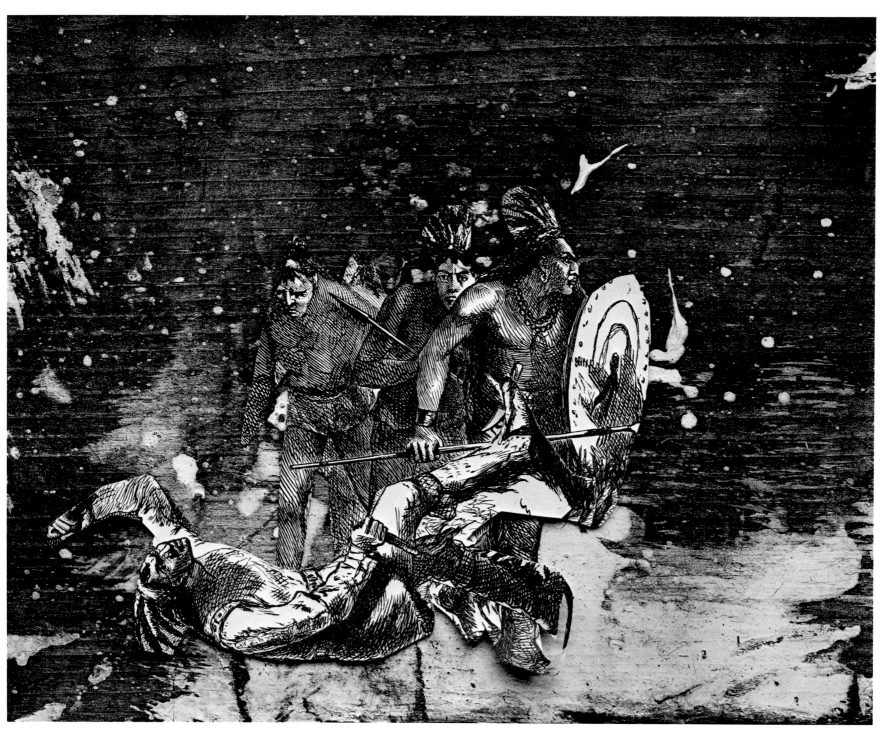

3

Foreword

This catalogue, which provides a permanent record of an exhibition honoring the significant photographic accomplishments of Frederick Sommer, is the happy result of a collaborative effort between the Delaware Art Museum and the photography program at the University of Delaware.

While the Museum was fortunate to host this impressive gathering of Mr. Sommer's works, full credit is due Professor John Weiss and his graduate students at the University, who conceived, researched, and assembled the exhibit and this catalogue.

From the outset, there was little doubt in our minds that this would be an important yet difficult undertaking. Frederick Sommer is a man of many parts—landscape architect, composer, philosopher, photographer, to name but a few. His vision has been pervasive, yet he has remained, either by choice or circumstance, an elusive figure in the growing pantheon of twentieth century image–makers.

John Weiss, himself a highly respected photographer and teacher, set out to remedy the situation and, after studying Sommer's photographs and writings, I also became convinced that there was an important story to be told. By combining forces, we felt we could mount an exhibition and publish a catalogue that would do justice to both the man and his important work.

Although we were dealing with an artist of known stature and substantial professional reputation, gathering information and examples of his work was always difficult, and at times, exasperating. Only by the most persistent efforts of Professor Weiss and his graduate students—Bobbie Wendel, Charles Metzger, Ed Mitchell, and Jan Fromer—were we able to assemble a representative group of his photographs and an extensive biographical summary of his life.

The fortuitous results of this collaboration can now be seen, and I take great pleasure in expressing my sincere appreciation to all who have made it possible. In particular, I commend my colleague John Weiss for his dedication, his vision, and his personal sacrifice of that most valuable commodity—time—to bring this all about.

CHARLES L. WYRICK, JR.
Director, Delaware Art Museum

Preface and Acknowledgments

A sequence of unexpected collisions with Frederick Sommer concluded with my visit to his home in Prescott, Arizona, in 1977. Provoked by a first, extended encounter with his photographs, I blurted out a proposal for an exhibition at the Delaware Art Museum. Eyebrows dancing with delight at the perfect irony of his response, Sommer had replied: 'Treat me like I'm dead.'

Well, exactly! For nearly forty years his work had been rationed by the thimbleful. A handful of shows, all but one a skeletal outline of his imagination, and two slender, long out-of-print monographs were hardly testimony to the measure of his vision.

In effect, his photographs had been consigned to a kind of visual graveyard, there to rest as little more than a footnote to photographic history.

Undiscouraged by Sommer's existential posture, I left Arizona determined to generate an exhibition. It was soon evident, however, that to simply *identify* a significant portion of his opus would require an expedition worthy of Magellan. One does not casually wander into photography's supermarkets, stroll down endless aisles stacked with Sommer's prints, and choose with abandon whatever pleases the eye. Though the exhibition even-

tually swelled to more than 100 photographs, they were gathered in mostly ones and twos from hidden pockets across the country.

Prospecting for the buried treasures of Frederick Sommer required a team of resourceful detectives. From the early, scuffling-for-clues days of the project, when each new sliver of evidence was cause for celebration, I have been assisted by BOBBIE WENDEL and CHARLES METZGER. Graduate students in photography at the University of Delaware, Wendel and Metzger have been my valued colleagues. They uncovered most of the original biographic material presented in this volume and tracked down many of the previously unknown photographs shown in our exhibition. Their critical attention to all phases of this enterprise has been essential and is gratefully acknowledged.

As it became clear that our initial intention to produce a relatively modest exhibition could be exceeded, that a major exhibition and catalogue were within reach, we enlisted the help of ED MITCHELL and JAN FROMER. Also graduate photography students at Delaware, their contributions have been significant. Mitchell's research into Sommer's artistic and philosophic antecedents gave substance to facts, while Fromer's creative administration solved numerous problems and kept us focused.

A network of supportive people has been indispensable to our endeavor. I am particularly obliged to VICTOR SCHRAGER and SUSAN HARDER, and to WILLIAM INNES HOMER, Chairman of the Department of Art History, University of Delaware, each of whom provided substantial early leads; to EMMET GOWIN, who encouraged us when it mattered the most; to RICHARD MENSCHEL and ROBERT MENSCHEL for the wisdom of their counsel and their continuing belief in the importance of our work; to DAVID P. BECKER for his kindness; to CYNTHIA JAFFE MCCABE of the Hirshhorn Museum and Sculpture Garden and to JAMES MCQUAID for generously sharing their considerable research; to JAMES ENYEART, Director of the Center for Creative Photography, University of Arizona, for helping us over several imposing barriers; to MARVIN HOSHINO and MARC FREIDUS for their assistance in resolving a number of matters crucial to the project; to ALEX JAMISON, who made useful suggestions that improved the chronology; to TERENCE R. PITTS, Curator and Librarian, Photographic Archives, Center for Creative Photography, who was kind enough to share his bibliography, thus confirming the completeness of our own; to PETER MACGILL and LARRY MIL-

LER, Associate Directors of Light Gallery, who saw to it that many of our goals were fulfilled; to AARON SISKIND for sharing a wonderful afternoon of reminiscences; to JONATHAN WILLIAMS, America's chronicler, for keeping promises; to the staff of the International Museum of Photography at George Eastman House for allowing us access to their research materials; to Professor JOSE ORRACA of the Art Conservation program at the University of Delaware, whose delicate touch restored several photographs; to STEPHEN PERLOFF, publisher and editor of *The Philadelphia Photo Review*, for his many considerations in times of need; to MELINDA PARSONS for making recommendations that were helpful in the construction of our chronology; to *Aperture* for permitting us to quote from their issues 10:4 and 16:2; to MICHAEL BARR and JOSEPH STERLING, and to GERALD NORDLAND, Director of the Milwaukee Art Center, for their many gestures of support; to LELAND RICE, whose own massive effort to show and publish Sommer's work is occurring simultaneously with our project, for his willingness to coordinate the reproduction of photographs, thus insuring an amplified presentation of images; to JOHN and JEANI GOODMAN, for providing new energy when it counted; and to PETER C. BUNNELL, Curator of Photographs, The Art Museum, Princeton University, for sharing his extraordinary fund of knowledge.

I take particular delight in recognizing my colleagues in the production sequence of this catalogue. Though their contributions are listed elsewhere in these pages, and while the evidence of their skills speaks for itself, I am grateful that RICHARD BENSON, SUSAN DEVINS, and KATY HOMANS have made this work their own. I also wish to acknowledge the superb craftsmen at the MERIDEN GRAVURE COMPANY for the remarkable fidelity of their renderings.

Finally, I have saved for last a special tribute to CHARLES L. WYRICK, JR., Director of the Delaware Art Museum. No one has ever had a more steadfast ally than Pete Wyrick. Only his absolute determination to construct the finest possible exhibition and catalogue kept this project from collapsing on several occasions. To paraphrase Frederick Sommer, it is because of Pete Wyrick's steely resolve that we have been able to 'do no less well than we could do.'

JOHN WEISS
Associate Professor of Art, University of Delaware

EDITOR'S NOTE

Understanding that interference automatically attends the editing of someone else's work, I have nevertheless attempted to *present*, and not define, the imagery and rationale of Frederick Sommer. In my essay, however, I have taken license to excerpt, categorize, and rearrange the chronology of Sommer's words. This has been done in the interest of cohesive narrative and, I trust, is faithful to original meaning. If these actions seem paradoxical to my opening statement, I can only say that intent is at issue — and besides, Sommer himself provides ample precedent for the process of restructuring.

Accordingly, direct quotes by Sommer appear in italics. They are taken from *Aperture*, volumes 10:4 and 16:2; Sommer's treatise, *The Poetic Logic of Art and Aesthetics*; from our personal conversations; and from various public lectures.

Because so many of Sommer's photographs have recurring titles (*Arizona Landscape, Cut Paper, Smoke on Cellophane,* etc.) and because many of his prints have acquired titles he never intended, a visual record of the exhibition accompanies this catalogue. The *Exhibition Checklist* labels images by title only when they have been confirmed. Conversely, when certain untitled photographs are generally known by adopted names, I have identified them within parentheses.

J. W.

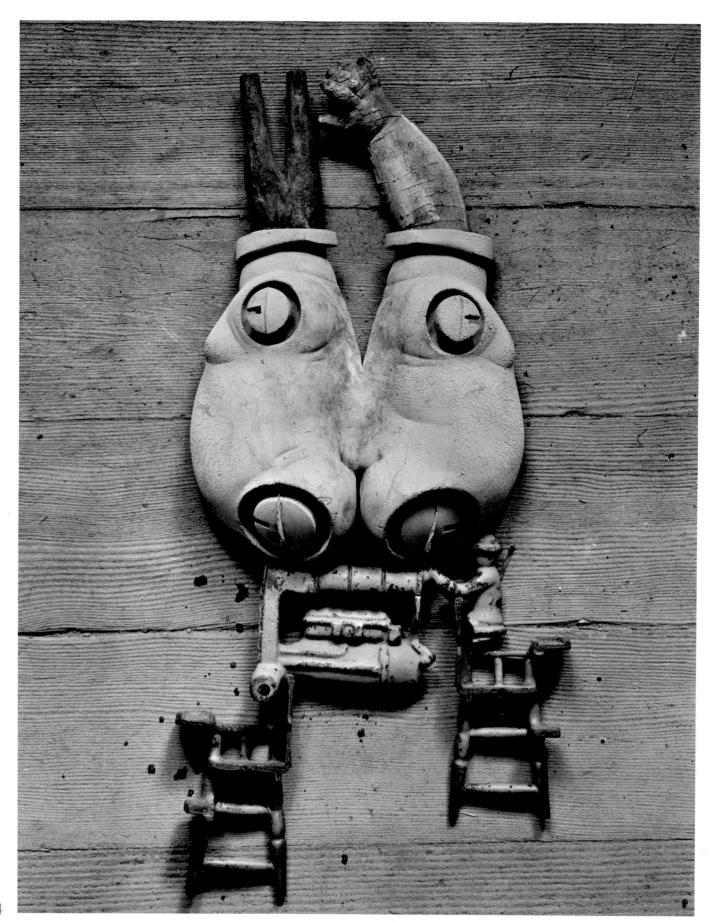

4

A Durable Fiction

JOHN WEISS

Frederick Sommer has been photography's best kept secret. Until recently, Sommer was the 'X Account' of the medium, a mysterious and shadowy figure lurking on the outskirts of our awareness. Fortune and circumstance conspired to place him in a position somewhere between the smugly tolerated and the ignored.

It is ironic that Sommer was neglected by a medium longing for recognition as art. In the 1950s, photography had ripened, but was uncomfortable with its newly privileged condition. Photographers and historians, sensing ascendant influence, began meeting to consider matters of destiny. Inheritors of Steiglitz's legacy, they organized a new power base. By their actions, they sanctioned the 'right' kind of photographs: documentary essays and idealized landscapes. In these councils, Sommer was easily dismissed. His methods were considered offensive, his imagery was impure. He was a trespasser.

I was the most disposable kind of photographer at one time. Some felt I was strange, concocted, unphotographic. They said I manufactured subject matter, that my work was pathological. Many people said I was doing the medium harm. Credibility does not like to be strained. And I know now, of course, that I didn't really strain people's credibility too much; they just weren't flexible.

I accept what happens. I don't say to myself, 'I wish this had not happened.'

While the best of his contemporaries found walls in prominent places to display their photographs, Sommer worked unattended in Arizona. While others concentrated on a singular viewpoint, making photographs that for all their power were easily packaged, Sommer staked claim to a diversified field. His boundaries were far wider and his vision was not so easily unraveled.

Sommer had come to photography with a kaleidoscope of interests. Trained as a landscape architect, he was also accomplished in drawing and painting. He had carefully, almost fastidiously, studied the great artworks. He had read physics and poetry, philosophy and literature. He had given significant attention to music and mathematics.

An educated and well-traveled man, indeed, a modern-day Renaissance man, it was natural for Sommer to consider an assortment of ideas. His style was to investigate what he didn't understand. He found it appealing to examine the seeming incongruities presented by the world. Entanglements only inspired possibilities for connections.

I think that only conflict, only confusion is ultimately the great creator.

All things are scrutinized in transit. Only as visitors do we understand something.

If you find yourself going to a zoo too often, it's because you belong there in the first place; you're at home there.

*The only way to understand something is to be
confronted by something that is difficult to
understand.*

*The coherent way of investigating any field
is to examine its possible relatedness to other things.*

*Everything is shared by everything else;
there are no discontinuities.*

*Our only objective should be
to follow the consequences of our moves—
only then can we make a blunder
or make something out of ourselves.*

*It doesn't make any difference what you do;
the important thing is that you give consent
to what you are doing.*

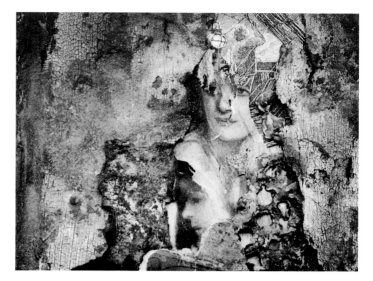

Circumnavigation of the Blood, 1950

Photography became Sommer's dominant medium for
linking so many of the notions that enticed him. His subjects
ranged from loved ones to decaying animal carcasses. He
intentionally put some things out of focus and rendered
others with exquisite detail. He photographed nudes; he
recorded a chicken's anus, an artificial leg, and an ampu-
tated foot. He photographed in the desert and in junkyards.
He collected found objects, often saving them for years be-
fore finally constructing an arrangement to photograph. He
cut paper into patterns with a knife and photographed the
harvest of his moves. He made cameraless negatives by
drawing on foil, then transferring the impression to glass or
cellophane. He used other artists' lithographs for back-
grounds or he sliced up their prints, piecing them back to-
gether to create a new and seamless image.

The photographs Sommer made from these techniques
were not always an end, but a stop on the way. They were
episodes in a continuing fascination with regeneration. At
times, he took part of one image and set it in another simply
because it fit there. Sommer wasn't shy about borrowing,
and the source made no difference.

Dürer Variation No. 1, 1966

*All rare things should be lent away
and I have borrowed very freely.*

Images have sources and antecedents.
To turn away from them is to have no image
to breathe life into.

I don't mind going back to orchards
whose fruits I can't name.

I constantly revise my stockpile of ideas.
The value does not diminish
because it has been revised, restacked.
The more beautiful the text,
the greater the chance you can reorder it.

The trading back and forth of ideas
is conducted by linguistic and pictorial logic.

Pictorial logic is visual order.

Art is at the service of visual order.
Art, under all conditions, has served position.

We are servants of structure.
Structure is understandable to us only as position.

Position is where something occurs.

I'm obsessed with the power of position
and the power of position is everywhere.

It is often more important to know
where a thing is
than what it is.

There is a distinction between where a thing happens
and what happens there.

Whatness is concerned with content
in the solemnity of every hour life returns.

Whereness is concerned with linkages
the legato of one squirrel holds the forest together.

As an elegantly rendered observation of totalities
a photograph or painting also invites participation.

The world is not a world of cleavages at all,
the world is a world of bonds.

If Sommer transposed images, there was precedent for his thinking. He had previously inspected the structures of literature. They suggested to him experiments in skip reading, a process by which he reordered words in a text. By random rapid selection of words said aloud, Sommer found he could form an extended logic. This revised distribution of language was grammatically sensible and coherent. It amplified the original meaning.

His allegiance to the underpinnings of things led him to another venture: he became attentive to the graphic quality of music. Impressed that the finest compositions were also beautiful drawings, Sommer suspected there was a high correlation between what a note signified and where it was positioned. He was delighted by the prospect that musical scores might be originated as design, *then* played as music. Encouraged by his musician friends, he learned notation to facilitate the testing of his theory. In time Sommer 'designed' dozens of scores and heard many of them performed.

For Sommer, structure was at the heart of all matters. Order demanded the harmonious positioning of things; it insisted on respect for gravity. If content was important, then economy of distribution was paramount. Sommer was focused on linguistic and pictorial logic.

Science was another agreeable target for Sommer's curiosity. He saw that physicists were probing the mysteries of life, investigating the natural order for structures that disclosed the patterns and frameworks of matter. If one was to

be intimate with the logic that nature reveals, then an alliance with physics was essential.

It became evident to Sommer that the methods and philosophies of science and art were reciprocal, in direct opposition to C.P. Snow's argument in *The Two Cultures*. Sommer suggested that, in many ways, the same kinds of interrelationships bound each discipline together and to each other. Though his fellow artists scoffed at such notions, thinking them peculiar, physicists were quite receptive.

In fact, in recent times, physicists have become strong advocates for such contentions. In Gary Zukav's book on quantum mechanics, *The Dancing Wu Li Masters*, support for Sommer's thesis is unmistakable. Zukav writes that scientists and artists are 'members of the same family of people whose gift it is by nature to take those things we call commonplace and to *re-present* them to us in such ways that our self-imposed limitations are expanded.'

Zukav goes on to address the questions of manipulation and intent, issues that seemed to segregate the aims of an impartial observer — the scientist — from an involved participant — the artist. He writes that 'according to quantum mechanics, there is no such thing as objectivity. . . . The new physics . . . tells us clearly that it is not possible to observe reality without changing it. . . . Our reality is what we choose to make it. . . . Not only do we influence our reality, but, in some degree, we actually *create* it. . . . Metaphysically, this is very close to saying we *create* certain properties because we choose to measure those properties. Said another way, it is possible that we create something that has a position . . . because we are intent on determining position and it is impossible to determine position without having some *thing* occupying that position we want to determine.'

To Sommer, science and art were fundamentally coincidental. They were mutually concerned with validating organic unity. They sought to clarify the order of things, to confirm and connect experience.

The world of art and the world of science
are interested in evidence and verification.

Art and science deal with evidence by way of position
in a harmonious flow of linkages.

The new physics speaks of things we cannot see,
but there must be order to what we call abstract.
It is wrong to think there is no structure.

We are interested in facts.
Facts are not dead objects,
facts are interrelationships of interrelationships
endlessly carried down to their consequences.

I do not see any fundamental difference
between art and science.
They are both serving our feelings;
they are both interested in respect for reality
and they are heavily weighed
on the side of sense perception.

Aesthetics is the only Greek word for sense perception.

Aesthetics celebrates art as the poetic logic of form.
Technology is only a special condition of general aesthetics.

Photography, in the right hands, is at the fulcrum of technology and art. Photography as art is the extended application of technology. Photographers have most frequently verified their art in nature. It is in the presence of nature that Frederick Sommer confirmed everything that was unresolved for him. His appreciation of structure was never more intensely acknowledged than when he was photographing nature. In the natural landscape, Sommer found perfect harmony and his vision was never more eloquent.

In nature, all the intellectual forces that compelled him gave way to instinctive awareness. He could be still with himself. He could say, as Rilke had, 'If you will cling to Nature, to the simple in Nature, to the little things that hardly anyone sees . . . if you have this love of inconsiderable things and seek quite simply . . . then everything will become easier, more coherent and somehow more conciliatory for you.'

Sommer embraced all of nature with dispassionate respect. No portion was ignored and no aspect was favored at the expense of another. As nature accommodated itself to all conditions, so did Sommer accept the landscape in all its forms. He was as attendant to the desert's efficient beauty as he was to its rotting animals. Once again, Rilke seems appropriate: 'We have no reason to mistrust our world. Has it terrors, they are our terrors; has it abysses, those abysses belong to us; are dangers at hand, we must try to love them.' Frederick Sommer simply trusted the natural world and clutched it to him.

It's fictitious to think that ideas in art
don't exist in reality.

There is no imagination, no flight of fancy,
that is not grounded in reality.

A superlative photograph, in its cohesion,
is a reintroduction to nature.

For verification, no matter how abstract the work of art,
the artist goes back to the world.

The fulfillment of a work of art
is to find itself again in nature.

Some speak of a return to nature,
I wonder where they could have been.

List of Plates

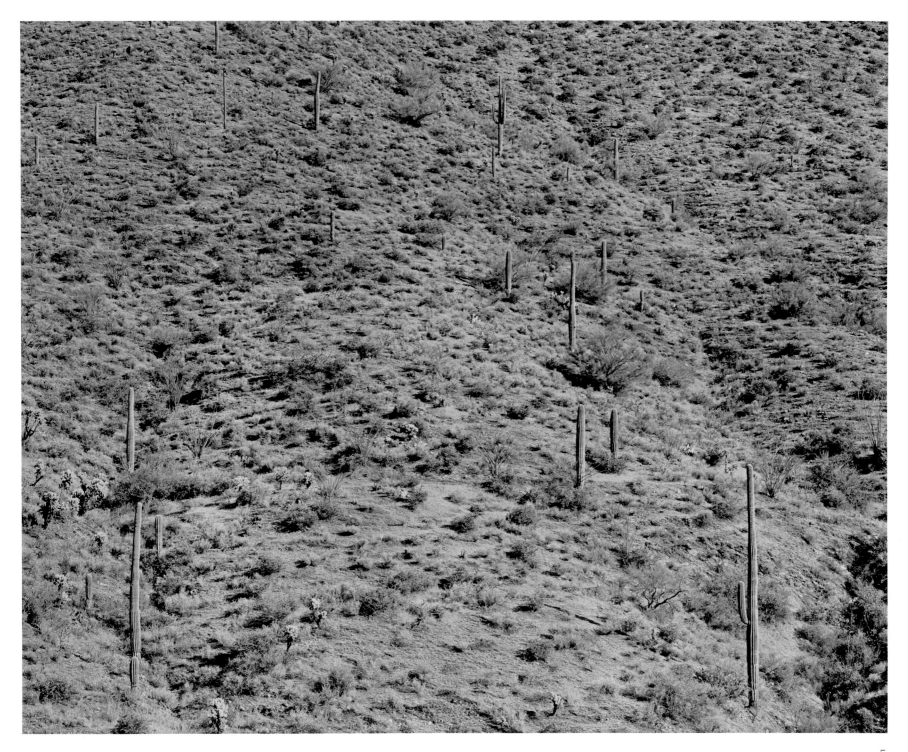

5

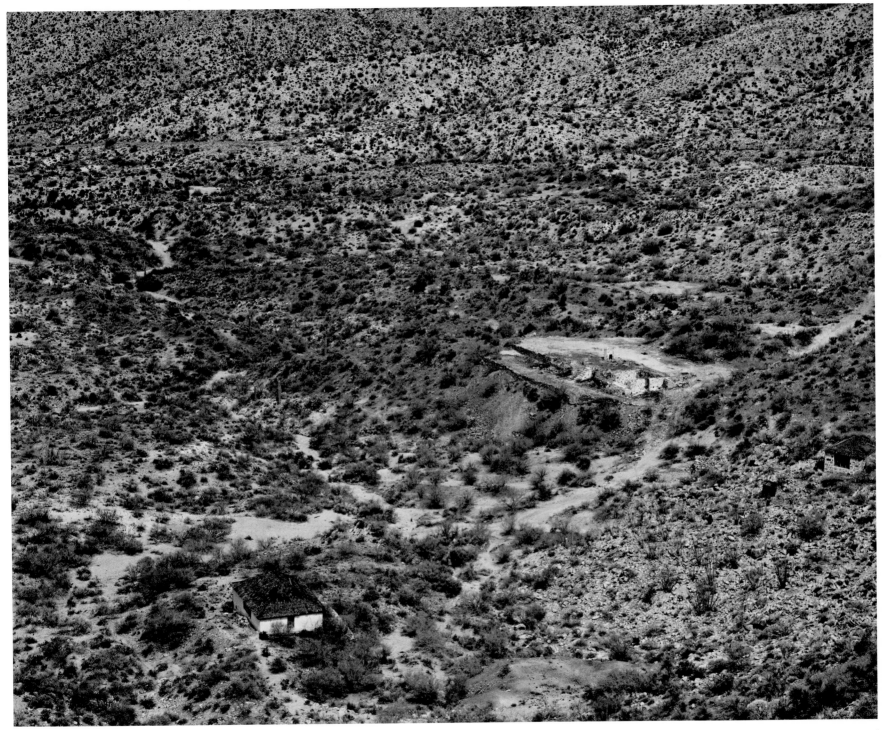

6

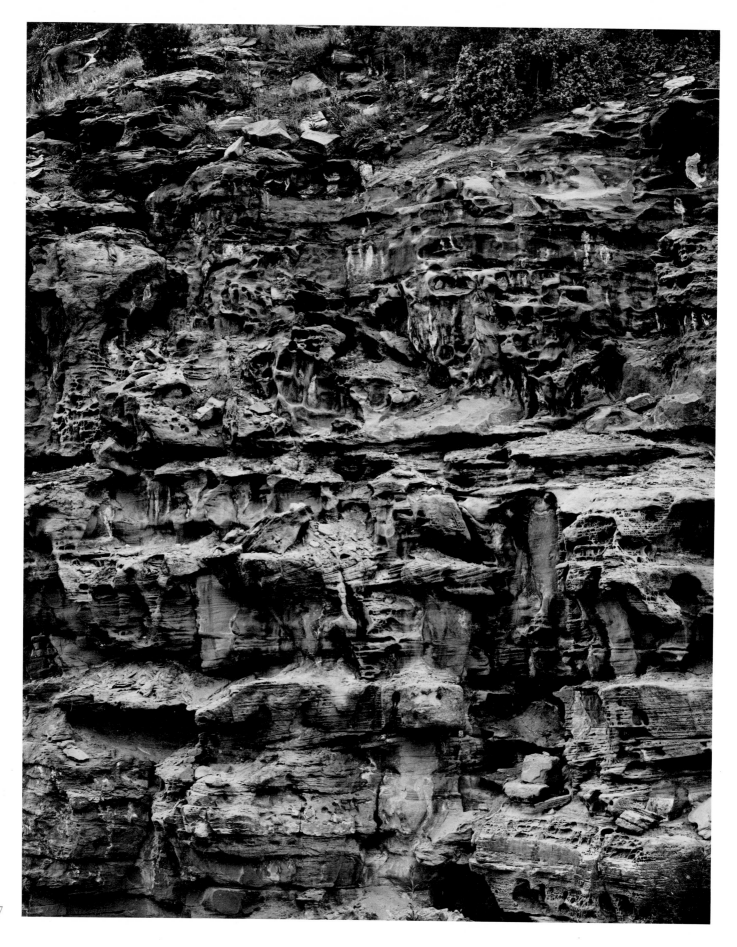

7

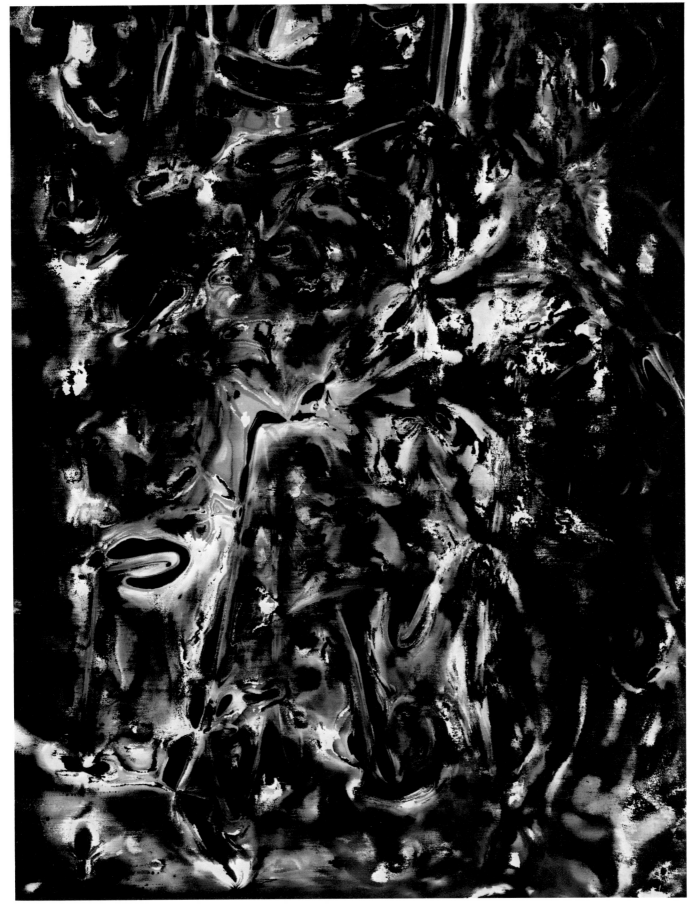

8

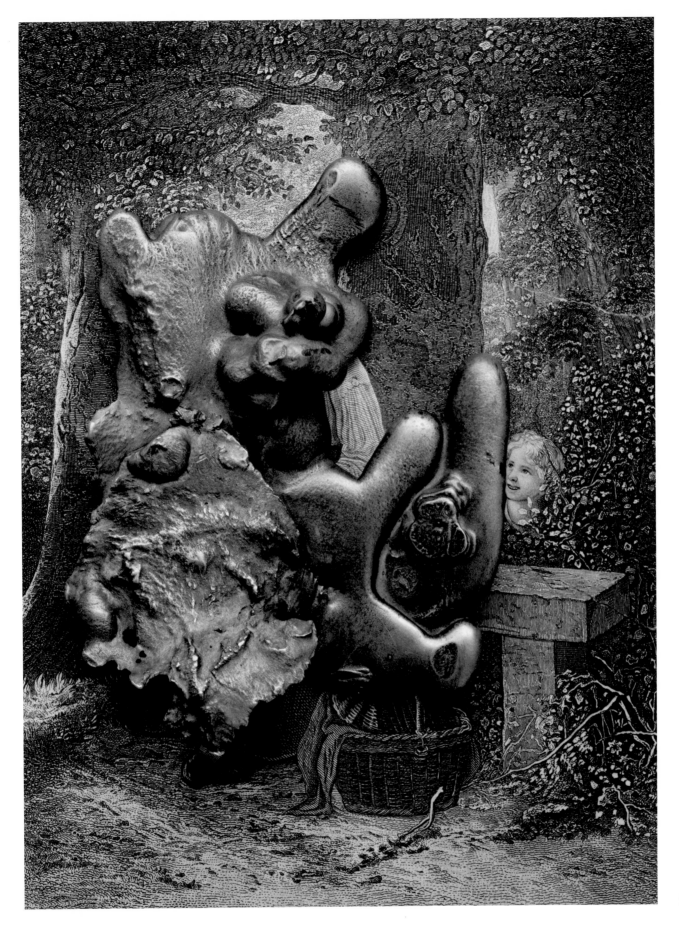

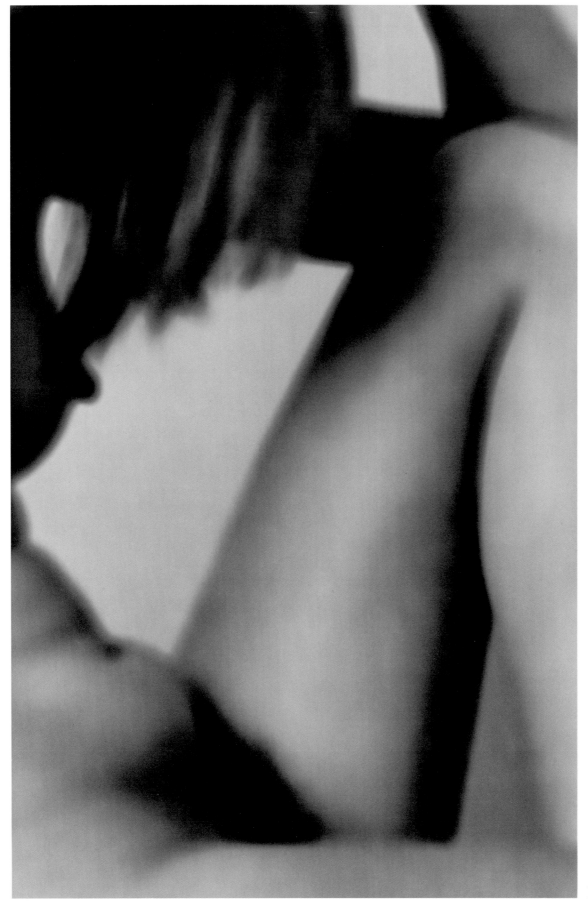

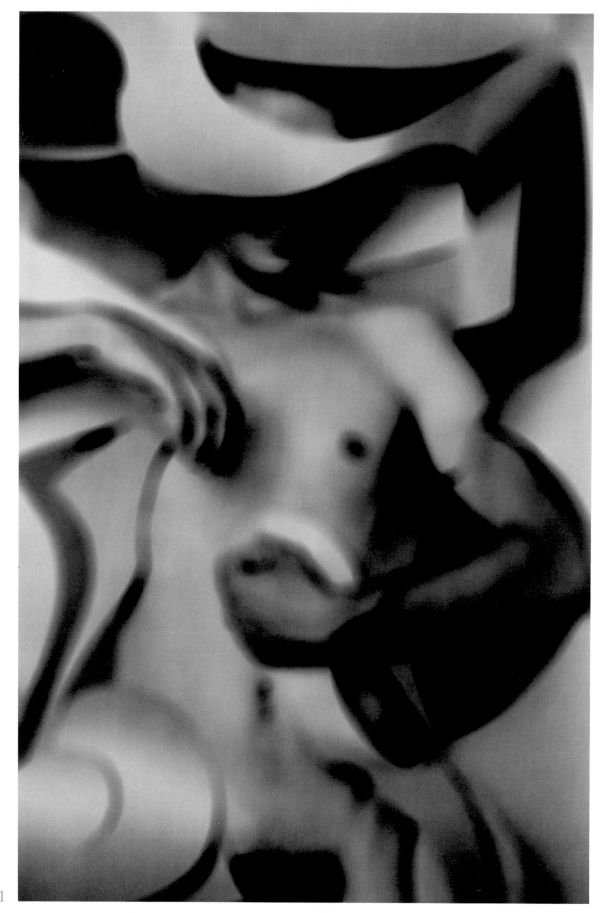

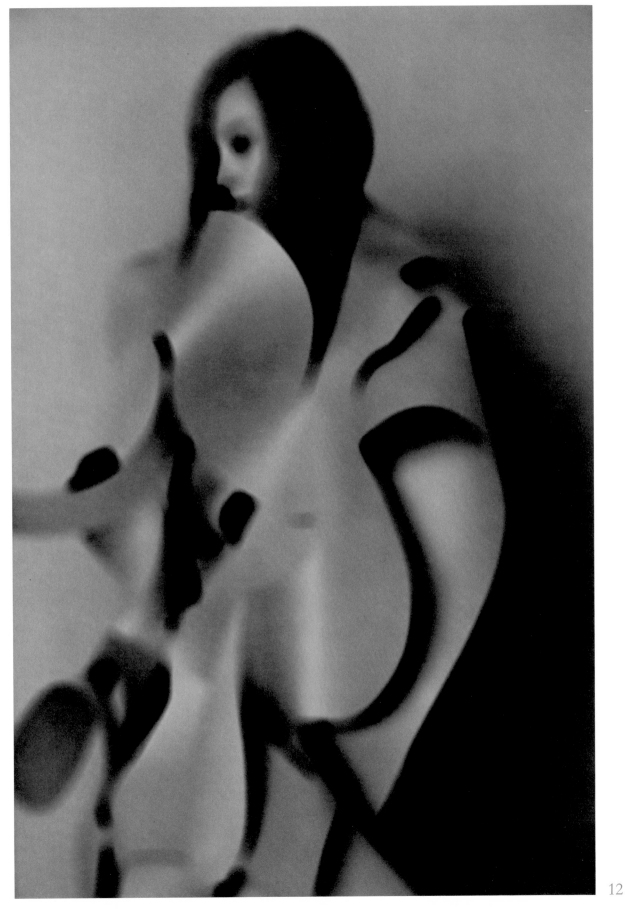

12

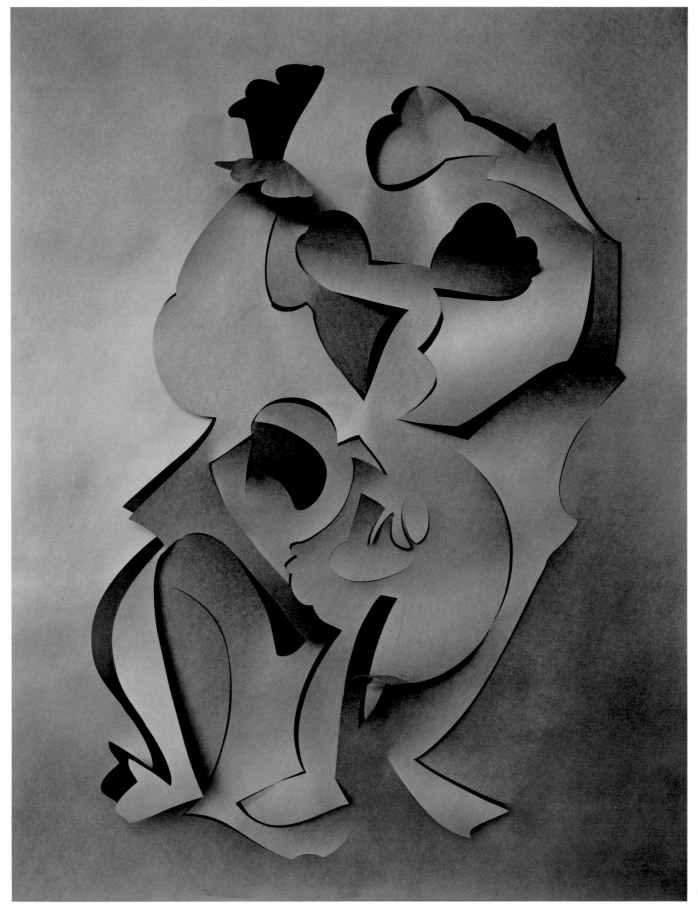

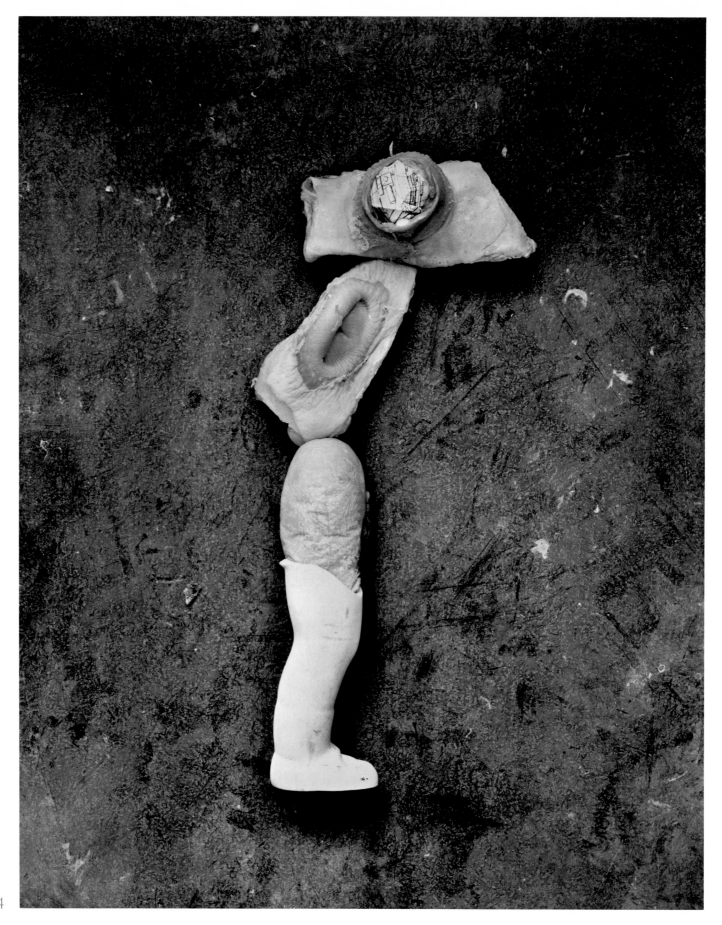

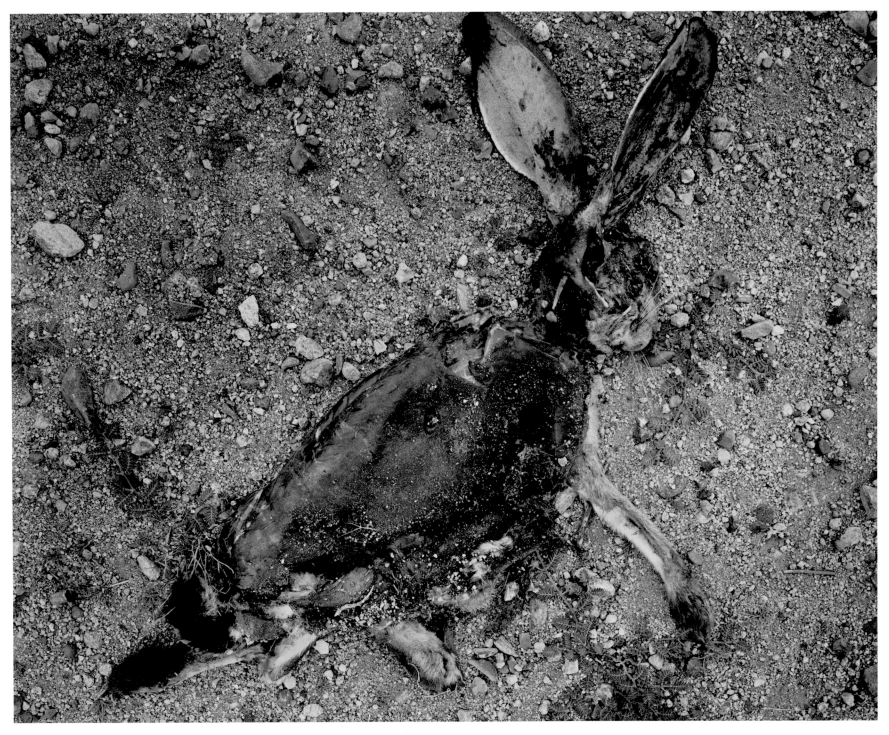

15

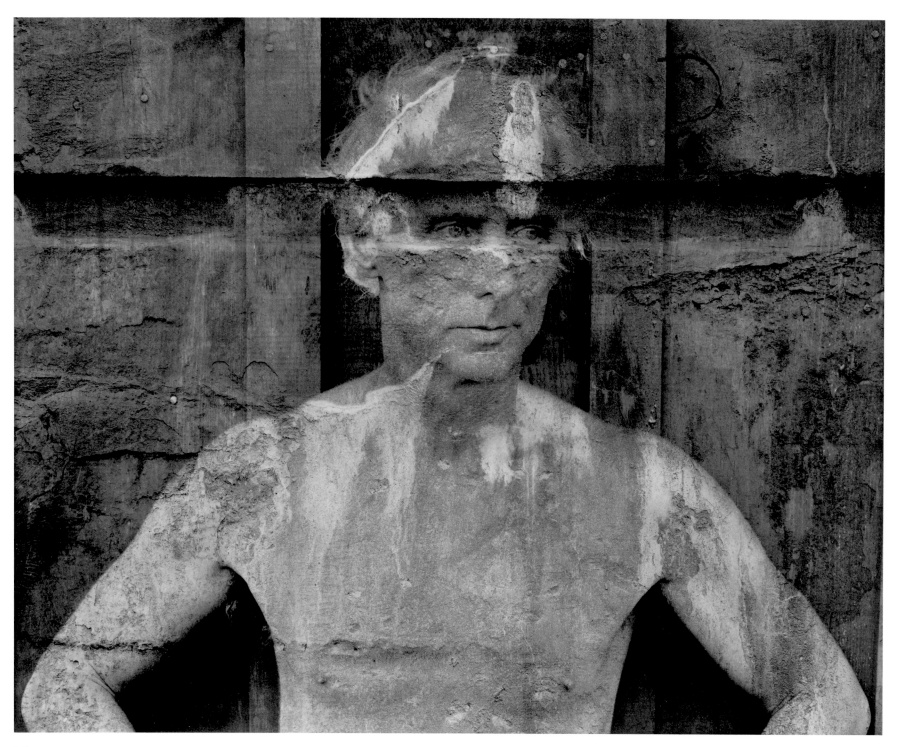

16

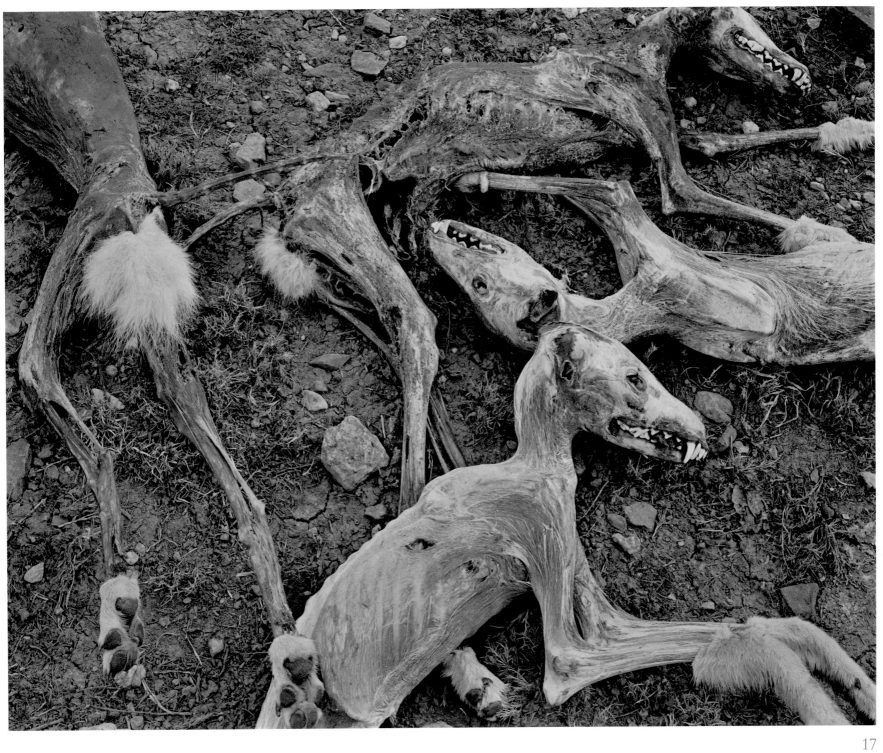

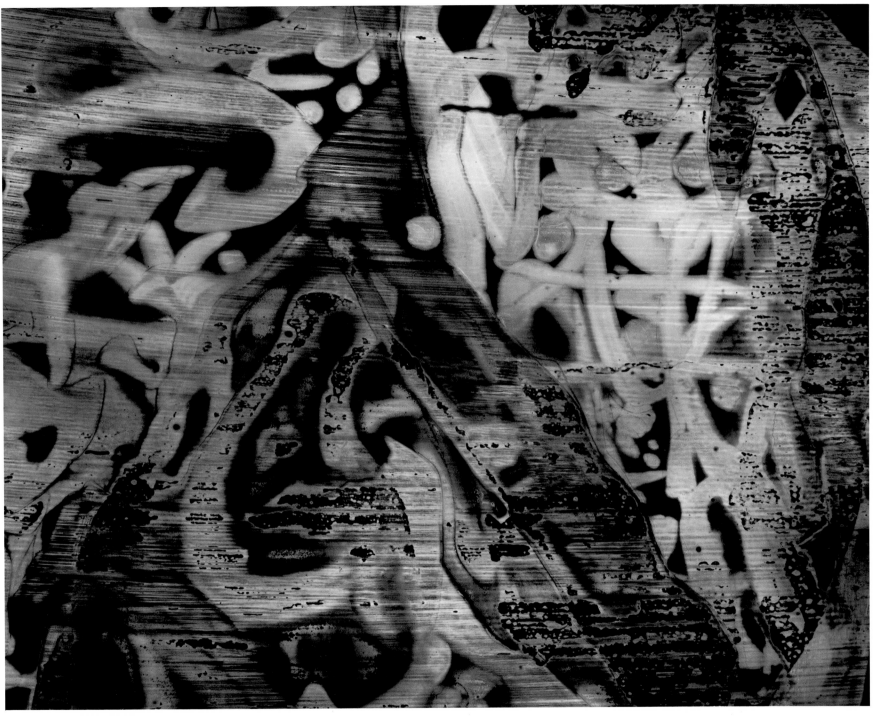

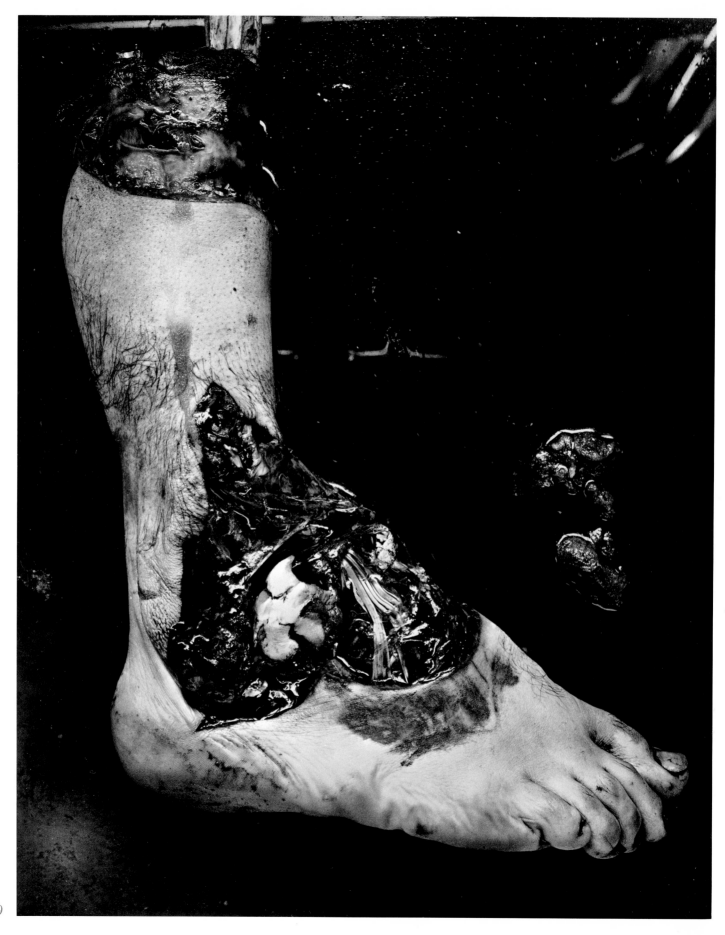

19

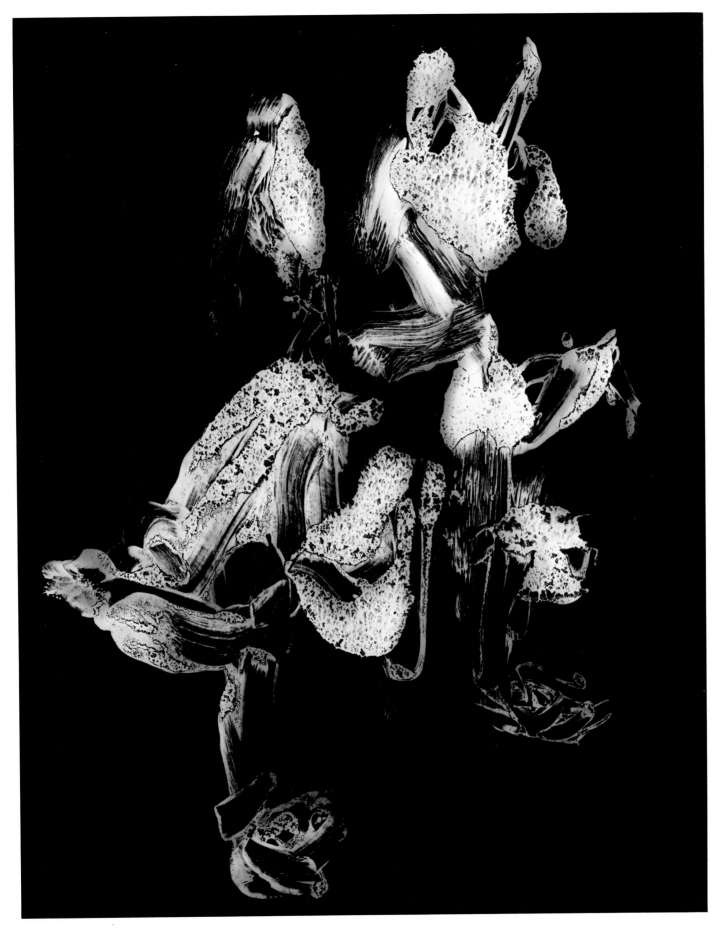

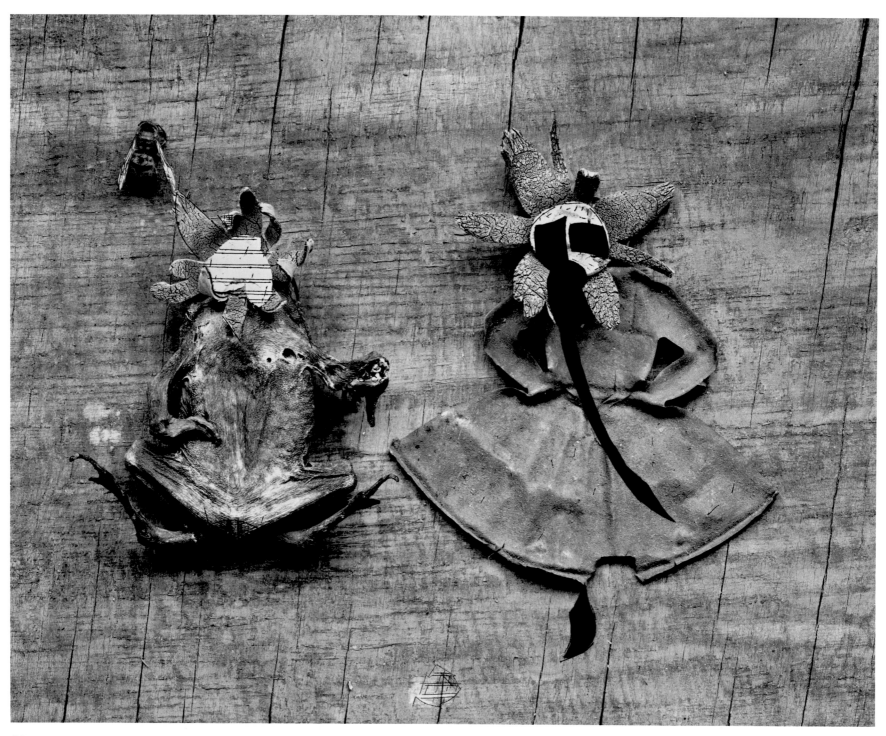

21

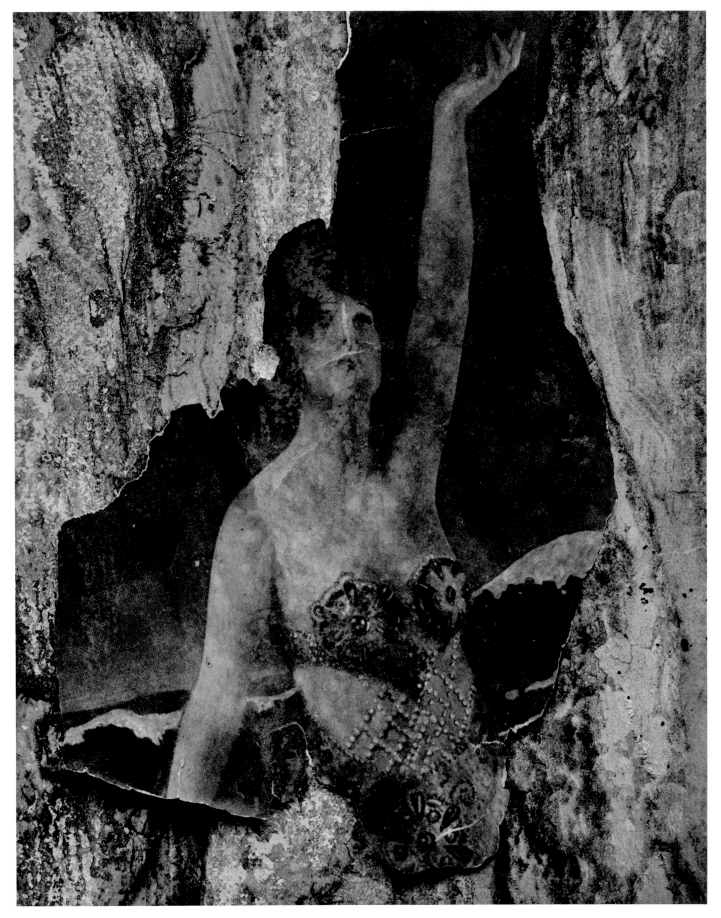

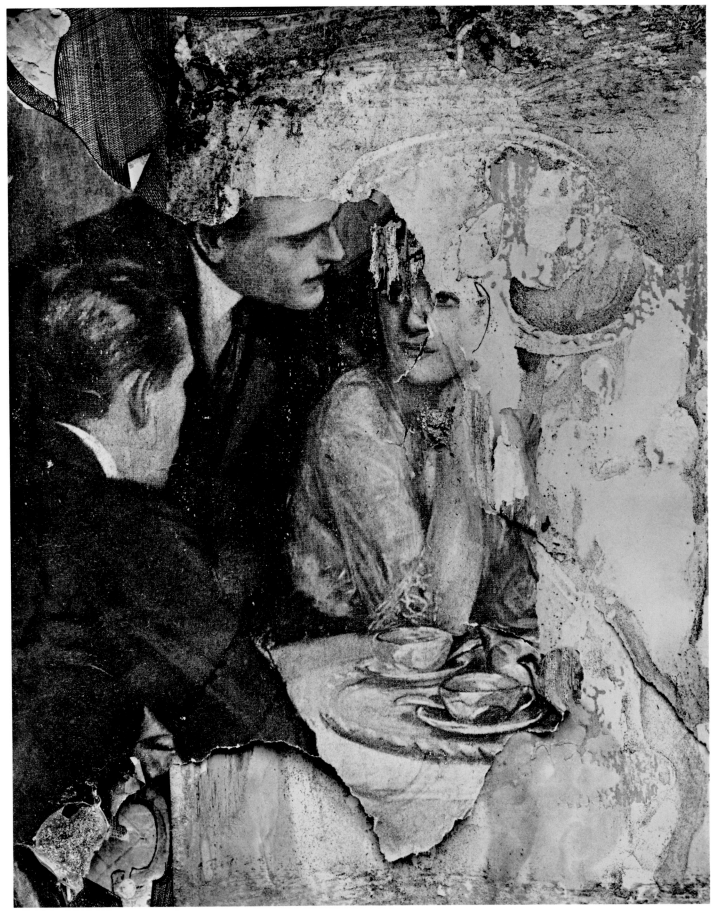

23

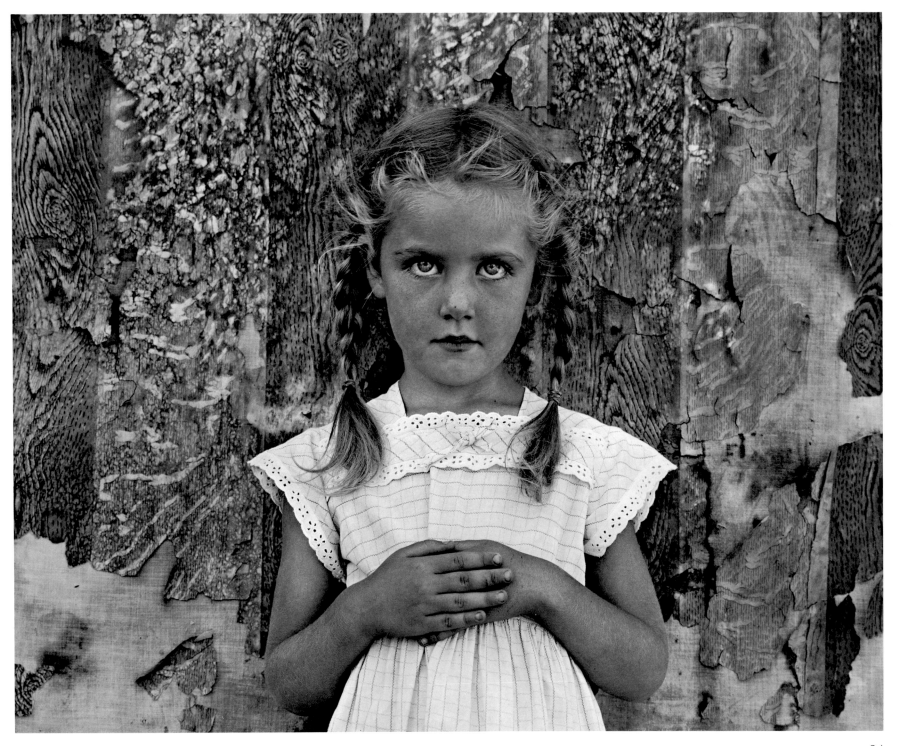

Homage to F.S.; or,
that old-time Ryne Duren—Rex Barney bailout

JONATHAN WILLIAMS

One dreamy, Kentish afternoon in the early nineteenth century, Mr. Blake said to his young-ancient friend, Sam Palmer: 'You have only to work up imagination to the state of vision and the thing is done.'

Precisely! Frederick Sommer has practiced this preachment for so many years—and I find a quote in my notebook that is entirely appropriate to this sentiment: 'It is a fine thing when a man who thoroughly understands a subject is unwilling to open his mouth . . .' [Yoshida Kenko]. I do not find it fulsome to declare flat out that Sommer's right up there in the Photographic Cooperstown Immortals League—along with the Bambino, Wondrous Willie, Terrible Ted, Hammerin' Hank, and the Georgia Peach.

But, since Tergiversation is my middle name, I have to go on further and note, for a start, another fine sentence from Kenko's *Essays in Idleness*, written in the Japanese court about the year 1331. *Viz:* 'The mark of an excellent man is that he writes easily in an acceptable hand, sings agreeably and in tune, and, though appearing reluctant to accept when wine is pressed upon him, is not a teetotaler.' Sommer does fulfill these civilized requirements.

I have an imploration from John Weiss to say something inspired—with imagination worked up to the state of vision—or at least something competent about an exhibition in the State of Delaware by Frederick Sommer of Prescott, Arizona. Here in a remote Cumbrian dale, I have no prints to look at. I have none of the brief catalogs and monographs devoted to the man, or even the few words I essayed about him in *Aperture* years and years ago.

All I have to offer—and I do mean *all*—is the sense of enthusiasm I have had for Fred Sommer and his prints since Aaron Siskind advised me to stop in Prescott during one of my early sorties amongst the Plastic Hydrangea People from Beyond Space—from whose number artists in America must find their minuscule crop of readers and viewers. One tries to be *attentive* and heed the quiet men and women who work more or less undisturbed by either *Boobus americanus* or Great Britain's omnipresent Lord Stodge.

We live in a world of infinite chitchat about artworks that leave the participants in this universe of discourse thinking they are indubitably superior to the images of simple-minded photographers. (Harry Callahan shook his head and said to me one time, 'You know, these critics say I don't understand what I'm doing. But, son of a bitch, the thing is: *I did it.*') I remember a conference in Washington, D.C., called something like Photography: Where We Are. Collectors, critics, archivists, speculators—about twenty of them. And among them, one politely resigned, restive photographer—Frederick Sommer—all but ignored in the deluge of rationality set forth by University of Chicago *philosophes* and by S. Sontag, the Queen of New York.

There are surely other ways of responding to photo-

graphs. Domenico Scarlatti suggests, 'Show yourself more human than critical and your pleasure will increase.' And again, Yoshida Kenko, who seems so useful, 'Can one imagine a well-bred man talking with the air of a know-it-all, even about a matter with which he is in fact familiar? The boor who pops up on the scene from somewhere in the hinterland answers questions with an air of utter authority in every field.'

Sommer is one of two men I know who revere Anton Bruckner as much as I do. It is such a rare pleasure to listen to a new recording or performance of a symphony in either's presence. On no occasion is much ever said. The quality of the attention is what counts, based on decades of private listening. And then the 'judgmental' stays in the background where it damn well belongs. You come to realize that Sommer is a photographer whose work demands this votive rapture. For there are times when I think I have never seen prints more luminous (I could also say *numenous*) than *Arizona Landscape, 1945*; *Dürer Variation No. 1*; *Venus, Jupiter & Mars*; *Coyotes, 1945*; or the portrait of *Max Ernst*. They are pauses to wonder.

I wish I had that baseball photographers trading card No. 111 of Sommer by Mike Mandel to look at now, something to get the signs from. I have always called him 'Fireball Fred,' Last of the Guys Who Could Throw Smoke in the Same Cave with Leonardo da Vinci. Daguerre, preserve us—what does that mean? I have everything in the house about Beatrix Potter, but not a syllable on Leonardo. But I recall that episode in his life when he stood in some cave or maybe in the basement of a church and looked at the stains on a wall and saw all things (a microcosm, a phantasmagoria) in the *chiaroscuro*, in the irregularities, in the discontinuities. It is that metamorphic strain in Sommer that unleashes his imagination and ours. I'm wracking the poor brain for the word that conveys this shape-shifting. It's not *anfractuosities*; it's not *rugosities*, though these words stick with me like burrs. They are somebody's prose in writing of Leonardo—Dali's maybe?—where he discusses that famous wall and the 'hypnagogic image of the phosphene of the retina.'

William Blake once said to George Richmond: 'I can look at a knot in a piece of wood till I am rightened at it.' Not far from the sort of gnomic wisdom that Fred Sommer delivers now and again; e.g., 'Some speak of a return to nature—I wonder where they could have been?' These men occupy a world of *delight*, in which nuance and adumbration are everywhere and all.

I'd like to apply to Frederick Sommer something that I discovered in A. H. Palmer's book on his father, Samuel: 'He had, he said, a "double vision", or power of seeing always in action, which with the rapidity and clearness of the photographer's lens changed many outward and visible objects to clear and often beautiful mental pictures. In this way, a tall thistle changes to an old man grey in years; and the stars to all the heavenly host shouting for joy. It is therefore no wonder that seeming trifles filled him, as he says, "full of smiles and tears". If we are repelled by his spirits and spectres, we can turn with relief to this transmutation, and find there is a wider and more natural field for a powerful imagination such as his.'

Bruckner, Blake, Leonardo, Sommer—a congeries of certain spirits. I can only suggest this to those with the right antennae. If that company seems too extraordinary, too rich, then stomp it on down. Remember those comfortable words of Duke Ellington: 'You've got to find some way of saying it without saying it.'

May Fred Sommer continue to throw that smoke. It's an honor to be awe-struck out.

Delay in Glass

ROBERTA HELLMAN AND MARVIN HOSHINO

All the current talk about photography's aesthetic is based on a persistent misconception. Most photographs have been made according to principles borrowed from narrative fiction or from painting and, even when they weren't, are still judged on this same borrowed aesthetic. Photography's own radical aesthetic was submerged very soon after its invention. You can still sense it in its naive state in the very earliest photographs, where technical luck counted for more than the photographer's taste. It was a miracle that an image could be captured at all. Traditional criticism, which is used to separating form from content (but always with the proviso that the two are inseparable), had no means of grappling with this autographic medium in which form and content aren't merely inseparable but identical. For the first time, an image could be fixed without human intervention by employing the very light the objects reflected. Almost too soon photographers gained enough technical control to afford the leisure of thinking in art's terms. By the time of Henry Peach Robinson and Peter Henry Emerson, photography was fully embroiled in the academic antagonisms: truth vs. beauty, form vs. content, expression vs. information, object vs. image. The century ended with pictorialism, photography's academic answer to academic art.

It is too easy to assume that Straight Photography perpetuated the Victorian oppositions by wanting both sharp-focus realism and photography as fine art. Quite the contrary, straight photographers tried to absorb the nonlinear space-time of modernism, but they didn't fully understand that their method—setting sharply defined objects in am-biguous space—was only indirectly modernist. The sharp focus was arrived at by a formalist analysis of photography's unique ability to render tone. The space came not from cubism, as is so often assumed, but from the flattened compositions of pictorialism. Put simply, the resulting tension between the certainty of the objects and the uncertainty of space allowed straight photography to share modernism's absurdist underpinnings. The best early example is Paul Strand's *White Picket Fence*.

The significance conventionally given to the next generation's use of the quick, small candid camera has long masked the fact that these photographers (who, after all, include not only Henri Cartier-Bresson and André Kertesz but also the large format users Walker Evans and Bill Brandt) were taking their lead not merely from the new technology but intentionally and systematically from modernism.

Evans's conceit, consistently photographing flat facades directly from the front, blurs the distinction between flattened and highly illusionistic space, and comes directly from cubism. Cartier-Bresson's 'decisive moments,' which blur the distinction between stillness and stop-motion, come from the nonlinear time of surrealism.

These photographs work only when the real world throws off, by chance, a clue that coincides *exactly* with the photographer's vision. Two succeeding generations of photographers and countless commentators have not noticed that while Evans's and Cartier-Bresson's tone is more restrained than Stieglitz's, their dependence upon coincidence is exactly parallel to Stieglitz's idea of the 'equivalent.' In

missing the connection between the two styles, photographers and commentators alike have been unable to grasp the point of either: You can't ask what the photographer does and what the real world gives when dealing with autographic art.

For forty years it has been assumed that Frederick Sommer lies outside the mainstream of photography. His appetite for subject matter and working methods makes other photographers look so picky by comparison that his work is always served in fragments, as though if it were taken together, it would clash with itself. With his view camera he could just as easily photograph the Arizona desert as an amputated leg he borrowed from a doctor friend. He has arranged found objects and bits of junk and made photographs of them. He has produced photographs from cheap reproductions of old wood engravings, torn and folded, and from automatic drawings, which he makes by slashing kraft paper with a razor. He has made sharp-focus portraits, nude studies carefully printed out-of-focus, and pictures of statues in which the camera was deliberately jarred at the moment of exposure. His cliché verre (cameraless negatives), produced from smoke-on-glass or paint-on-cellophane, can be figurative or nonfigurative. He has even done some little-known 35mm street photography.

But it is the Arizona landscapes, photographs that lack a horizon or a central subject (perspective and emphasis having been suppressed in favor of exquisitely rendered detail) that are generally acclaimed. Photographers have understood them in terms of Westonesque view-camera perfection. Painters have been able to relate them to Tanguy's contemporaneous rock paintings and to the flat, compositionless paintings that followed. Sommer's other work has been tolerated as interesting but arcane (an assemblage picture titled *The Thief Greater Than His Loot*, for example) or simply disagreeable (the anuses of *Eight Young Roosters*). Sommer is seen in the backwash of Surrealism—the friend-of-Max-Ernst and the user of well-worn ideas and methods, such as automatic drawing and the cult of the creepy object.

So often his pictures have been thrown into specialized contexts that tend only to emphasize the least interesting common denominators between his work and that of others. In 1960, he appeared in the Museum of Modern Art's photography exhibit 'The Sense of Abstraction,' where, significantly, his were among the very few noncamera images that were figurative. He has been classified for his strange subject matter and included in such exhibits as 'Human Concern/ Personal Torment,' the Whitney Museum's Vietnam-era show of 'the grotesque in American art.' More recently, he was included in 'Picture Puzzles,' the Modern's show of 'arranged' photographs.

What has been needed is this retrospective to show that by unifying its disparate schools, Sommer lies at photography's very center. Photography took Marcel Duchamp's ready-mades to legitimize camera work; Sommer finally applies the 'machine aesthetic' evenhandedly: If objects made by camera have expressive possibilities *equal* to those made by hand, there is no difference between a camera photograph and a cliché verre. And by taking the surrealist notion of collaborating with chance to its logical conclusion, Sommer dismisses photography's sacred distinction between the found and the arranged: There can be no difference between a subject the photographer finds 'intentionally' and one he creates by 'chance.'

When Sommer met Alfred Stieglitz in 1935 he saw firsthand what the photographer as artist could do. And the following year he began his friendship with Edward Weston. As the 'documentary' work from the Guggenheim period shows, Weston was really successful only when dealing with the beauty of the natural form. Sommer saw immediately how the raw power of Weston's tonalities could be made to serve additional ends.

Photography has generally agreed with Weston's pro-

nouncement that one of its advantages is that you can make pictures as fast as you can see them. Sommer had already learned from Duchamp that, even with a machine, you can make pictures only as fast as you can understand them. Sommer slows the seeing down. While other photographers count their pictures in the thousands, Sommer counts his in the hundreds. He studied the Arizona landscape for days before making the first exposure, and he has been known to hold on to an odd scrap of material for years before discerning how it might be photographed. Sometimes he takes months deciding whether or not a print has 'finish,' and refuses to reprint an old image unless it offers new possibilities of meaning to him.

Sommer comes out of Weston and then takes a giant leap away from abstract expressiveness toward the full meaning of art as myth. Form becomes not an end in itself but art's servant. His photograph of a junkyard mound of glass shards becomes an exalted vision of hell. *Paracelsus*, rendered from paint dripped on cellophane, remembers the medieval alchemist of Robert Browning's poem. Sommer does not, as many contemporary artists have, seek refuge in what are for us romantic pseudo-myths from anthropological or Eastern sources. He has confronted our own culture by returning to the sacred and profane imagery of Western art before the Renaissance. That's why Sommer's pictures were so out of place in the Whitney's 'torment' show. His universe is calm, embracing even mutilated animal corpses, robots made from parts of toys, and statues turned into spirits. In a picture of coyotes—killed and skinned by bounty hunters and left to rot—death smiles for Sommer as it did for Holbein. Sommer has been able to make pictures with a density not seen in Western art since Van Eyck, as if he alone has understood the potency of photography's automatic image-making process.

In 1839 a minor French academic painter, Paul Delaroche, upon learning of the invention of photography, is reputed to have said: 'From today, painting is dead.' And eighty years later a major French modernist painter gave up painting. Duchamp: 'I wanted to put painting once again at the service of the mind . . . I was endeavoring to establish myself as far as possible from "pleasing" and "attractive" physical paintings.' As William M. Ivins, Jr., has argued in another context, the split between the informational and expressive functions of art began long before photography; it coincided with the start of the Renaissance and was the result of the age of mechanical reproduction. Photography, the *ne plus ultra* of graphic art, is supposed to have exaggerated the split, first inducing abstraction in painting and, in reaction, provoking Duchamp. When Duchamp's ready-mades too quickly became beautiful sculptural forms, he could outwit aesthetics only by pretending to give up art altogether. Had he been dreaming of cameras and not chocolate grinders, it might have occurred to Duchamp that photography could solve his dilemma by giving him automatically all the density of information that progressive painters since the era of mechanical reproduction have been bothering with less and less. Duchamp had all the machinery, but he couldn't consummate his art. What, after all, is *The Large Glass*, if not a cliché verre, perhaps the largest ever conceived? And his final work: *Given 1. The Waterfall, 2. The Illuminating Gas*, which, by forcing the viewer to look at a tableau from the fixed vantagepoint of a peephole, virtually turns him into a camera, shows how close Duchamp came—to Frederick Sommer.

Portions of this essay were published in the article 'Frederick Sommer,' in *Arts Magazine*, June, 1977.

Chronology

BARBARA WENDEL AND CHARLES METZGER
WITH ED MITCHELL

1905

Born Fritz Sommer, September 7, in Angri, Italy, a small town three miles from Pompeii. First child of Carlos and Julia Sommer; German father and Swiss mother had met in Italy.

1909

Father's occupation as horticulturalist results in family moves through Germany and Switzerland. Fritz and younger brother, Enrici, speak first Italian, learning German as second language.

1913

Moves with family to Sâo Paulo, Brazil. The move, motivated by father's love of warm climates and the luxuriance of tropical plants, proves providential with the coming of World War I. Fritz, now known as Frederico, learns Portuguese and begins formal education at a German school.

1916

Family relocates to Rio de Janeiro, where father establishes flourishing landscape architecture firm and nursery. Father's enthusiasm for the structural aesthetics of the natural environment awakens in Frederico a special awareness of the landscape. An early penchant for drawing is supported, his interest in his father's work is encouraged, and at age eleven, Frederico is assisting by doing architectural renderings. Continues formal education at German school, later transferring to Portuguese-language Benedictine gymnasium.

1921

At age sixteen, wins second prize in major architectural competition to plan a park and recreation area in Rio de Janeiro.

1922

Encounters variety of new architectural styles and ideas at World's Fair in Rio. Buys folding Kodak camera to photograph the pavilions. Will occasionally make other photographs for architectural study.

During summer holidays, works as apprentice in architectural offices. Independently studies art and architecture in father's extensive library.

1923

Encouraged by a community that does not discriminate against youth, takes private landscape commissions. Accepted into circle of Brazilian poets and writers; publishes several essays in literary magazines.

1924

Meets William Gratwick, American businessman and amateur horticulturalist. Gratwick, interested in locating certain Brazilian plants, is referred to the Sommer nursery. Impressed by the young Sommer, Gratwick suggests he come to the United States to gain experience in the new landscape architecture being done there.

1925

Travels to the United States. Contacts Gratwick, who invites him to his estate in Batavia, New York. Gratwick refers him to various area architects; a chain of references follows, leading to an introduction to Edward Gorton Davis, head of the Landscape Architecture Department at Cornell University.

Struck by the exuberant and colorful style of Sommer's renderings, as well as his multilingual ability, Davis hires him as an assistant in his private practice. Davis encourages him to audit university lectures and eventually to register as a special student. He becomes Sommer's intellectual mentor and provides a second home, easing the cultural transition.

1926

Enrolls at Cornell as a graduate student in architecture. When confronted by his lack of traditional academic credentials, obtains letter of certification in architecture and fine arts from Brazilian Ministry of Education. Pursues varied studies, from Italian Renaissance gardens to city planning under Professors Davis, Edward Lawson, and W. H. Schuchardt.

Meets future wife, Frances Watson, a Cornell student doing graduate work in education.

1927

Receives Master in Landscape Architecture degree. Thesis, *Villa Alba: A Residential Property*, is a plan for a Tuscan villa and gardens, fitted to an island site.

Following a visit to Aledo, Illinois, to meet Frances's parents, Sommer returns to Rio, forming a business partnership with his father. Firm becomes known for high quality innovative design, attracting many prominent Brazilians as clients.

1928

Marries Frances on August 23 in United States. Later that year, they move to Rio de Janeiro.

1929

Le Corbusier lectures in Rio, advocating modernism in architecture. Afterwards, Sommer defends Le Corbusier's revolutionary theories to his architect friends who are still committed to the tradition of Brazilian colonial architecture. Finds that his experience in the United States, his sympathy to structuralistic principles, and his international outlook have placed him in the avant-garde.

1930

Awarded Gold Medal, Pan American Congress of Architects, Rio de Janeiro.

Health declines. After a physical collapse on May 23, Sommer is diagnosed as suffering from tuberculosis. Advised to seek a climate that will allow him to recuperate, he decides on the health spas of Arosa in western Switzerland. Within two weeks, he and Frances are on a boat to Europe.

En route, the ship docks in Barcelona. Familiar with the unique architectural style of Antoni Gaudi, he is eager to visit the cathedral and many other Gaudi buildings. Attends International Exposition held in Barcelona, and is particularly impressed by the Mies van der Rohe pavilion.

Arrives in Italy and spends a week in Rome, visiting museums and the gardens at Frascatti and Tivoli. Learns from a friend of the death of Edward Gorton Davis. Many years later, discovers that his mentor's death had occurred on the same day as his own collapse.

From Italy, travels to Arosa and takes a room in a boarding hotel. Local doctor prescribes regimen of rest and moderate exercise.

Sommer will later say that his bout with tuberculosis and his time in Arosa prepared him for the years ahead. At first plagued by uncertain health and worried about the future, he finds that the relaxation that comes with rest brings an accommodation to his condition, an understanding that one must accept circumstances as they present themselves.

Appreciating the luxury of this time, he opens a new phase of his education, immersing himself in the study of philosophy and art. He reads Croce's *l'Esthetique*, Burkhardt's *The Culture of the Renaissance in Italy*, and the works of Spinoza and Nietzsche, all of which he considers basics. Buys art books and a magnifier with which he examines plates of old master drawings.

Returns to sketching and, for the first time, considers photography for its own sake. Purchases two cameras, a $2\frac{1}{4}$″ x $3\frac{1}{4}$″ Plaubel Makina and a folding Zeiss Ikon in the same format. Relies on commercial processing until a friend shows him how to develop and print his own photographs in the hotel's small basement darkroom. Makes contact prints on gold-toned printing out paper.

1931

Having regained his strength, plans to leave Arosa and return to the United States. Is temporarily delayed by the wait for an immigration visa. Goes to Paris, where the American consul promises him the first one available.

In Paris, Sommer is primarily interested in studying Renaissance art. Examines originals of drawings he has inspected in books. A growing interest in modern art, sparked by his reading in Arosa, leads him to investigate Cezanne, Matisse, the Cubists, and Futurists. Reacts to Cubism as formal design, enjoying it in the sense of a plan. In the Jeu de Paume, responds strongly to the sculpture of Boccioni, especially *The Development of a Body in Space.*

Following a brief circuit through Italy, visiting museums and gardens, Sommer returns to Paris, where he obtains his visa. Arriving in New York in June, he goes directly to Aledo, where he and Frances stay for several months with the Watson family.

With the onset of the harsh Illinois winter, they decide to leave for California's more healthful climate. Driving west, the Sommers stop to visit friends in Tucson. Taken by the haunting beauty of the desert, they

nall and unsophisticated western town will
ties to practice innovative landscape archi-
done in Brazil — Sommer refuses to compro-
terests. Begins a systematic study of modern
as a vocation, painting in a geometric, archi-

a painter trained at the Pennsylvania Academy
y set up a studio for private art classes, Marlow
mer watercolor, drawing, and design.

Mexico.

rld's Fair. Visits galleries and meets Increase
ho agrees to exhibit his work at her gallery the
shows him Edward Weston's first book of
d Weston, recently published by Merle Armi-

v of watercolors at the Increase Robinson Gal-

Los Angeles. Frances studies social work at the
alifornia, preparing for a job with the State of

Los Angeles Fine Arts Library, Sommer discovers a music library, where he is struck by the visual beauty of musical scores on display. He becomes fascinated with the notion that scores considered the finest music are also the most exciting as graphic design, sharing a visual coherence and elegance of notational distribution. He speculates that musical composition can be approached initially as drawing, creating the musically satisfying from the visually handsome.

Drawing, as we all know, is the backbone; it's what holds the sardine together.

F. S.

Aware of the support Merle Armitage has given to other artists, Sommer visits him in Los Angeles. Armitage appreciates Sommer's work, and the two become good friends.

1935

Frances's new job relocates them to Prescott, Arizona. In spite of the isolation of this setting, Sommer manages to maintain his sense of connection to the world of art.

Writes to Alfred Steiglitz at An American Place and sends him watercolors. They are returned with a letter of encouragement. In November, Sommer travels to New York, seeing Stieglitz almost every day of the week he spends in the city. Meets Georgia O'Keeffe, who suggests to Stieglitz that they show Sommer's work. Stieglitz replies he can no longer take on new artists, but gives Sommer introductions to other galleries and dealers. Sommer returns to Arizona, greatly encouraged and with a new view of photography in relation to the whole of art.

You're lucky if you have a teacher who in talking with some enthusiasm, conveys to you the sense of involvement. The only lesson is in the commitment.

F. S.

1936

To California for two weeks. Visits Armitage again, showing him drawings and small photographs. Armitage suggests Edward Weston should see them. Meets Weston in Santa Monica, and a strong friendship ensues. They exchange work, drawings for prints. The clarity, tonal range, and sensuality of Weston's photographs are a revelation to Sommer. They reinforce his own growing inclination to more fully explore photography. Weston introduces Sommer to Walter Arensberg and to Howard Putzel, a gallery owner.

1937

One-person show of watercolors and drawings at the Howard Putzel Gallery, Hollywood, California. Several drawings are sold to the English collector, John Davenport, who later donates them to the San Francisco Museum.

Begins a series of black-ground drawings in pigmented glue.

1938

Trades the cameras he had purchased in Switzerland for an 8″ x 10″ Century Universal view camera. An old 210mm Zeiss Tessar lens proves to be ideal for the series of close-ups he now begins. The change in photographic format provides the impetus for an outpouring of ideas. By his third box of twelve sheets of film, Sommer has made some of the images he still shows today.

Continues for the next ten years to make paintings and photographs that are largely independent of one another: the paintings—abstract, structural studies; the photographs—exquisite renderings of the particular and specific. The earliest photographs, made in the desert near Prescott, are still lifes, close-ups of organic discards, animal carcasses, and entrails. Reflecting a cool, dispassionate acceptance of the object, Sommer's vision mirrors the character of the desert environment.

1939

Begins a series of photographs of chicken heads and entrails collected from a local butcher. On Thursdays, the poultry arrives fresh to market, plucked but not drawn. Sommer, watching the butcher discard these guts, is captivated by their potential visual power. He recognizes the force and immediacy these objects will carry when photographed with the 8″ x 10″.

A doctor friend, who is also a photographer, asks Sommer if he would be interested in other unusual things. Not sure that the doctor is serious, Sommer indicates he might be. One evening, the doctor arrives with a neatly wrapped package. Sommer opens it to find a recently amputated foot belonging to the victim of a train accident. While the wheel marks are still clearly visible, he photographs it.

Experiments with 8″ x 10″ Kodachrome, but is dissatisfied with the effects of color on the unity of the image field.

Creates his first musical scores based on his theories of musical graphics and the aesthetic substructure common to all forms of art.

November 18: becomes naturalized U.S. citizen.

1940

Travels east. Visits Charles Sheeler, whom he had originally met through Edward Weston in California. During a two-day stay at Sheeler's Connecticut home, Sommer is impressed that Sheeler's paintings and photographs 'are not ashamed of one another.' This recognition is significant to Sommer, who is now working in both media.

1941

Begins a series of horizonless landscapes that form an important stylistic break. Stepping back from the concentrated vision of the still lifes, this new work is a nonselective examination of a wider visual field —distant allover patterns of rock and cactus.

In California, he is invited to bring his photographs to a Beverly Hills party attended by some well-known Surrealist artists. He takes both chicken images and the new landscape photographs. The work quickly becomes the object of a friendly argument between Max Ernst and Man Ray, who jokingly dispute who had appreciated the photographs first. Ernst invites Sommer to visit him in Santa Monica the next day, and delighting in each other's company, an important friendship begins.

Sommer's increasing adherence to Surrealist ideas concerning found objects and the appropriateness of the accidental in art finds confirmation

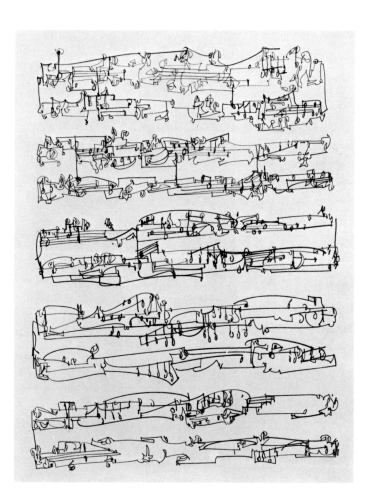

in Ernst and his circle. From the 1940s on, Sommer more fully embraces a Surrealist vocabulary in his life and art, taking pleasure in the confounding and ironic.

Faurest Davis, a friend and musician, suggests that they try playing the 'scores.' Sommer agrees, but is confronted with the problem of adding signature and key. He proposes instead that Davis be interpretive, feeling that the visual structure of the scores will be sufficient guide to the music. The results confirm his contention that the relative position of something is more important than its assigned value. This intensifies his developing awareness of the relationship between distribution and content — 'position' and 'occupier.'

1943

Ernst visits Sommer in Prescott for the first time and selects work for publication in the Surrealist magazine, *VVV*.

1944

First publication of Sommer's photographs (two landscapes) as well as four drawings, in *VVV*.

1946

First one-person show of photographs at Santa Barbara Museum of Art. Review in *Santa Barbara News Press*, 'Photos Feature Desert in Less Idyllic Aspects,' describes the still life and landscape pictures as 'forceful, striking, and in some cases even macabre. Many of the photographs are definitely unpleasant, yet they powerfully describe one phase of nature as Sommer has seen it and certainly this is one function of art.'

About this time, Sommer begins photographing assembled found objects, fanciful constructions that are transformed by the camera into seamless experiences.

Photographers are originators of an imaginative reality, of which the fantastic is a part.

F. S.

1947

Meets Charles Egan in Arizona. Egan, a New York art dealer and early supporter of the American Surrealists and Abstract Expressionists, is responsive to his work. He becomes Sommer's dealer and refers many East Coast artists to him on their trips out west.

Through Man Ray meets a photographer, James Fitzsimmons.

Fitzsimmons insists that Edward Steichen, curator of photography at the Museum of Modern Art, see Sommer's photographs. With a letter of introduction from Fitzsimmons, Sommer sends work to Steichen. Though initially disturbed by Sommer's imagery, Steichen comes to appreciate and support his vision.

1949

One-person show of photographs and drawings at Egan Gallery, New York City.

At Egan's suggestion, Aaron Siskind, who is traveling across the country, visits Sommer in Arizona. He stays with Sommer for several days before renting a cabin nearby. Siskind remains in Prescott for three months, seeing Sommer every day and using his darkroom.

Siskind and Sommer play Surrealist 'games' together, and Sommer entertains by 'skip reading.' He feels that this process of random selection and restructuring of written words, a verbal equivalent of his collage technique, can uncover new meanings inherent in a text.

They make a number of photographic expeditions together. Once, on a visit to the ghost town of Jerome, Arizona, Sommer does not take a camera. At the end of the day, Siskind returns to the car to find him napping. Awakening, Sommer holds up a handful of peeled-apart X-rays he has found on the floor of an abandoned hospital, announcing with delight, 'I've got my film already developed!'

Sixteen photographs included in exhibition 'Realism in Photography' at the Museum of Modern Art. Steichen purchases first Sommer photographs for the Museum collection.

Begins experimentation with synthetic (cameraless) negatives.

1950

Represented in 'Photography at Mid-Century,' an exhibition at the Los Angeles County Museum of Art.

1951

Meets Yves Tanguy, who is visiting Max Ernst and Dorothea Tanning in Sedona, Arizona.

Included in Museum of Modern Art exhibition 'Abstraction in Photography.'

Participates in first Aspen Conference on photography, 'The Camera and Reality: A Photographic Seminar,' with, among others, Berenice

Abbot, Ansel Adams, Laura Gilpin, Dorothea Lange, Beaumont New-hall, Eliot Porter, and Minor White. Although Sommer's work meets fierce resistance from most conference participants, who view it as 'unphotographic,' he is encouraged by the few who acknowledge its importance.

While in Aspen, meets Emerson Woelffer.

1952

Thirty-eight works, including backgrounds and fragments of objects used in making the assemblage photographs, exhibited in Museum of Modern Art show 'Diogenes with a Camera.'

1953

Sixteen photographs included in exhibition 'The West' at the Colorado Springs Fine Arts Center.

Represented in exhibition 'Contemporary Photography—Japan and America,' National Museum of Modern Art, Tokyo.

1956

Group exhibition, 'Contemporary American Photography,' Musée d'Art Moderne, Paris.

1957

Produces body of abstract photographs that relate to the earlier black-ground drawings. By squeezing and manipulating oil paint between small sheets of cellophane, Sommer creates synthetic negatives, which are then enlarged.

Meets poet and publisher Jonathan Williams, who visits him in Prescott at Aaron Siskind's suggestion. Williams will continue to visit regularly and uses several of Sommer's photographs as cover illustrations for his publications.

Appointed Lecturer in Photography, Institute of Design, Illinois Institute of Technology, as one-year replacement for Harry Callahan. Teaches studio photography and a design course, in which students are required for one assignment to design the perfect insect.

Lives with Siskind while in Chicago. Sommer, a notable chef, prepares the meals.

While he was with me in Chicago, Fred didn't do much work. He did other things: bought a lot of books, some new lenses. And he didn't feel restless or guilty about not working—Fred's not like that. He's not like Harry [Callahan] and me—if we don't work for a few days, we start to feel bad.

AARON SISKIND

I cannot work faster than I can taste or live what is happening.

F. S.

In Chicago, meets Richard Nickel, an architectural historian and photographer. They become close friends.

Exhibits drawings, paintings, photographs, and objects in one-person show at the Institute of Design.

Buys a Leica 35mm camera.

1959

One-person show of photographs at Wittenborn Gallery, New York.

1960

Travels three months in Europe, visiting museums and photographing. Blurred nude of Frances made just before the trip inspires a series of blurred images of sculpture and tapestries.

You have to go to the mother lode and the mother lode is simply the tradition of Western art which is accessible to us.

F. S.

Included in exhibition 'The Sense of Abstraction' at Museum of Modern Art.

First photographs of Lee Nevin, daughter of a Prescott neighbor.

1961

Executes series of *Smoke on Cellophane* prints, accomplished by transferring candle smoke deposited on glass to 3″ x 4″ sheets of greased cellophane, then enlarging the 'negative.'

Represented in exhibition 'Twentieth Century American Art' at the Kalamazoo Institute of Arts.

1962

Minor White publishes *Aperture* 10:4, 'Frederick Sommer, 1939–1962, Photographs,' which Sommer himself designs.

Included in '50 Great Photographs from the Museum Collection' at Museum of Modern Art.

First *Cut Paper* images. By rapidly drawing on large sheets of paper with a knife, then hanging the paper in light, Sommer creates patterns of lines and volumes to photograph. While the act of cutting the paper grows out of Surrealist ideas of the 'automatic,' the image structure derives from Sommer's response to particular works of art.

Begins a series of *Smoke on Glass* prints. Drawing with a stylus on aluminum foil and coating the foil with smoke, the image is then transferred to a greased glass plate and enlarged.

I know that photography has a way of handling some things well and I make more of these available than I could find in nature. If I could find them in nature, I would photograph them. I make them because through photography I have a knowledge of things that can't be found.

<div align="right">F. S.</div>

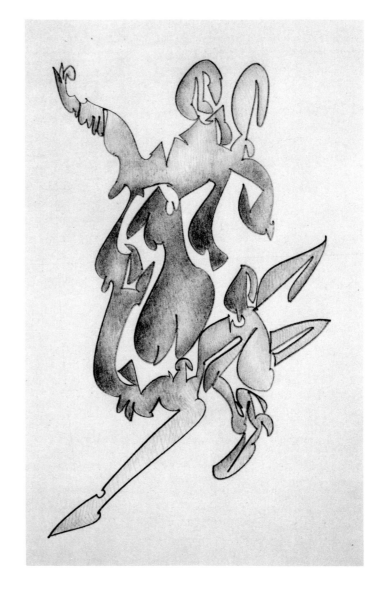

1963

One-person show of forty recent photographs, Art Institute of Chicago.

Lectures at Institute of Design, Illinois Institute of Technology.

1964

Represented in exhibition 'Photography 64/An Invitational Exhibition' at George Eastman House, Rochester, New York.

Thirty-two prints included in 'Art in Photography' at Cleveland Museum of Art.

1965

One-person show of photographs, drawings, and objects at Washington Gallery of Modern Art, Washington, D.C., organized by Gerald Nordland. Show travels to Pasadena Museum of Art, where thirty-eight prints are acquired for permanent collection.

Represented in 'Photography in America: 1850–1965' at Yale University Art Gallery, New Haven, Connecticut.

1966

Begins tenure as Coordinator of Fine Art Studies, Prescott College, Prescott, Arizona, a position he holds until 1971. Among other courses, teaches Bioesthetic Physics with Dr. John Stewart, a retired physicist from Princeton University.

1967

One-person show at Museum of Northern Arizona, Flagstaff, Arizona.

Exhibits in 'Three Photographers: Wynn Bullock, Edmund Teske, Frederick Sommer' at San Fernando State College, Northridge, California.

Included in exhibition 'Six Photographers' at University of Illinois, Urbana.

Teaches summer photography workshop at San Francisco Art Institute. In the fall, lectures at Rhode Island School of Design, Providence, Rhode Island, where he meets Emmet Gowin.

Exhibits in 'Photography in the 20th Century,' prepared by the George Eastman House for the National Gallery of Canada.

1968

First public performance of Sommer's musical scores at Prescott College by two students: Stephen Aldrich (piano) and Walton Mendelson (flute). The scores are projected above the two musicians who interpret the unconventional notation through mutually agreed-upon translations.

One-person show of 125 photographs at Philadelphia College of Art. Major exhibition catalogue published. Show travels to San Francisco Museum of Art, Rhode Island School of Design, and Institute of Design, Chicago.

1969 ·

Three prints in exhibition 'Human Concern/Personal Torment: The Grotesque in American Art' at Whitney Museum of American Art, New York. Show travels to University of California, Berkeley.

Travels to Japan. Spends six months in Kyoto studying Japanese art and culture, and photographing.

1970

Delivers extemporaneous talk at Art Institute of Chicago, published in *Aperture* 16:2, 1971.

Private performance of Sommer's music recorded at Joseph Sterling's home in Chicago.

1971

Signed as one of original thirteen artists to be exclusively represented by Light Gallery, New York City.

Teaches workshop at The Center of the Eye, Aspen, Colorado.

1972

Publishes *The Poetic Logic of Art and Aesthetics* in collaboration with Stephen Aldrich. The book includes a eulogy, 'Words Spoken in Mem-

ory of Richard Nickel at a Gathering of His Friends,' given by Sommer that year at Glessner House, Chicago.

Lectures at Imageworks and at Massachusetts Institute of Technology, Cambridge, Massachusetts.

Lectures at three San Francisco Bay area schools: San Francisco Art Institute, San Francisco State College, and California College of Arts and Crafts, Oakland. Musical scores performed at San Francisco Art Institute.

Included in group show at Fogg Art Museum, Cambridge.

Takes part in five-day retreat at Sippewisset on Cape Cod with: Peter Bunnell, Carl Chiarenza, Allan Dutton, Jonathan Green, Robert Heinecken, Jerome Liebling, Jack Welpott, Minor White, and Jerry Uelsmann. This extraordinary gathering brings together geographically separated friends and colleagues for a sharing of work and ideas.

Teaches workshop at Apeiron, Millerton, New York.

One-person show of photographs at Light Gallery. Musical scores are performed at the opening. Lectures at Cooper Union in conjunction with the exhibition.

1973

One-person show at Columbia College Photographic Gallery, Chicago.

Photographs included in the following group exhibitions: 'Landscape and Discovery: An Exhibition of Photography,' Hofstra University, Hempstead, New York; 'Light and Lens: Methods of Photography,' Hudson River Museum, Yonkers, New York; 'Photographs from the collection of the University of New Mexico,' University of New Mexico Art Museum, Albuquerque; photographs from the collection of the Minneapolis Institute of Arts at the College of Saint Catherine, Minneapolis, Minnesota; 'Photography in the 20th Century,' George Eastman House.

Teaches one month, substituting for Harry Callahan, and exhibits at Rhode Island School of Design.

Presents lectures 'The Primordial Image,' 'The Photographic Display,' and 'Subjective Structure' at Hamline University, St. Paul, Minnesota.

Gives second workshop at Apeiron. Takes an apprentice, Alex Jamison, whom he had met at Apeiron the previous year. Jamison remains with him in Prescott until 1978.

Indiana University acquires a collection of Sommer's photographs.

1974

Awarded Guggenheim Fellowship for photography.

Included in group exhibition, 'Light at Lunn,' Lunn Gallery, Washington, D.C.

Teaches workshop with Wynn Bullock, Linda Connor, and Clarence John Laughlin in Yosemite Valley.

Travels to England, Italy, Morocco, Greece, and Yugoslavia.

1975

Exhibits in 'Picture Puzzles' with Man Ray, Clarence John Laughlin, and Robert Cumming at Museum of Modern Art.

Teaches workshop at Sun Valley Center for the Arts and Humanities, Sun Valley, Idaho.

1976

Represented in 'The Golden Door: Artist Immigrants of America, 1876–1976,' an exhibition at Hirshhorn Museum and Sculpture Garden, Washington, D.C., and in 'Photographic Process as Medium,' Rutgers University Art Gallery, New Brunswick, New Jersey.

Major collection of Sommer's photographs acquired for the archive at Center for Creative Photography, University of Arizona, Tucson.

Extensive taped interview for George Eastman House 'Oral History Project' conducted by James McQuaid in Prescott.

1977

Exhibits over thirty works on paper, made since 1940, at Light Gallery.

'Honored Guest Photographer' at national meeting of the Society for Photographic Education in New York City.

Two-person show with Ansel Adams at The Arizona Bank Galleria, Phoenix, Arizona, and group exhibition, 'The Target Collection of American Photography,' Museum of Fine Arts, Houston, Texas.

Travels to New Zealand.

1978

Included in group exhibitions: 'Dada and Surrealism Reviewed,' organized by the Arts Council of Great Britain; 'Forty American Photographers' at the E. B. Crocker Art Gallery, Sacramento, California; 'The Photograph as Artifice,' The Art Galleries, California State University, Long Beach, California.

Presentation of paper, 'Pictorial Logic,' with Alex Jamison at the Corcoran Gallery of Art, Washington, D.C., during symposium 'Photography: Where We Are.'

New apprentice, Thomas Carabasi, arrives in Prescott.

Celebrates fiftieth wedding anniversary.

1979

Appointed Visiting Senior Fellow of the Council of the Humanities and Old Dominion Fellow in Visual Arts at Princeton University, Princeton, New Jersey. In conjunction with the opening of an exhibition of his work at the Princeton Art Museum, presents lecture, 'The Linguistic and Pictorial Logic of General Aesthetics: A Discussion of the Ornamental Sense of Ideas.'

Exhibits at Light Gallery.

Represented in exhibitions 'Abstract Photography in America,' Syracuse University's Lubin House, New York City, and 'Approaches to Photography—a Historical Survey,' Amarillo Arts Center, Texas.

1980

Included in group exhibitions: 'Prints in the Cliché-Verre: 1939 to the Present' at Detroit Institute of Arts, Detroit, Michigan; 'Light Abstractions' at University of Missouri, St. Louis, Missouri; 'Photographic Surrealism,' opening at the New Gallery of Contemporary Art, Cleveland, Ohio, and traveling to the Dayton Art Institute, Dayton, Ohio, and Brooklyn Museum, Brooklyn, New York.

One-person traveling show organized by Leland Rice, opens at California State University, Long Beach, California. Major catalogue published.

Bibliography

BARBARA WENDEL

1927

Sommer, Fritz. *Villa Alba, A Residential Property*. Master in Landscape Architecture Thesis, S 687, Cornell University, 1927.

1944

Péret, Benjamin. 'La Pensée est une et indivisible.' *VVV*, No. 4, February, 1944, pp. 9–13, 54–55.

1945

'Voices from the Wilderness.' *Minicam Photography*, Vol. 8, No. 4, January, 1945, pp. 30–31.

1946

McAllister, H. E. 'Photos Feature Desert in Less Idyllic Aspects.' Santa Barbara News Press, November 10, 1946.

1949

deKooning, Elaine. 'Frederick Sommer.' *Art News*, Vol. 47, No. 10, February, 1949, p. 45.

Deschin, Jacob. 'Individual Styles: Exhibit Contrasts Work of Four Photographers.' *New York Times*, July 31, 1949, Section II, p. 10.

Hunter, Sam. 'Salmagundi Club Holds Art Show.' *New York Times*, February 18, 1949, p. 31.

Maloney, Tom, ed. 'Frederick Sommer.' *U.S. Camera Annual, 1950*. International edition. New York: U.S. Camera Publishing Corporation, 1949, p. 292.

1950

Photography at Mid-Century. Los Angeles County Museum of Art, Los Angeles, 1950.

Wyss, Dieter. 'Eine Einfuhrung und Deutung Surrealistischer Literatur Und Malerei.' *Der Surrealismus*. Heidelberg, 1950, pp. 83–84.

1951

'Abstract Photography—A Vital Question.' *Photo Arts*, October, 1951, pp. 6–23.

Louchheim, Arline B. 'Abstraction: Camera Versus Brush.' *New York Times*, May 6, 1951, Section II, p. 8.

Van Dyke, Willard. 'Presentation: A Whale of a Difference.' *American Society of Magazine Photographers' News*, September, 1951, pp. 4–5.

1952

Belknap, Bill. 'Boulder Camera.' *Boulder City* [Nevada] *News*, July 3, 1952, p. 2.

Breitenbach, Joseph. 'Look Here, Diogenes!' *Infinity* (ASMP), May, 1952, pp. 7, 14.

'Diogenes with a Camera.' *Photo Arts*, September, 1952, p. 278.

'Photography at the Museum of Modern Art.' Special issue of the *MOMA Bulletin*, Vol. XIX, No. 4, 1952, p. 14.

Plaut, Fred. 'The Museum of Modern Art Christmas Show.' *U.S. Camera Annual, 1953*. New York: U.S. Camera Publishing Corporation, 1952, p. 168.

1953

Exhibition of Contemporary Photography: Japan and America. National Museum of Modern Art, Tokyo, 1953.

The West: A Portfolio of Photographs. Colorado Springs Fine Arts Center, Colorado Springs, Colorado, 1953.

1954

Barr, Alfred H. Jr., ed. *Masters of Modern Art*. New York: Museum of Modern Art, 1954, p. 197.

T., S. 'Frederick Sommer.' *Art Digest*, Vol. 28, No. 12, March 15, 1954, p. 27.

1955

Newhall, Beaumont. 'The Aspen Photo Conference.' *Aperture* 3:3, 1955, pp. 3–10.

Soby, James Thrall. *Yves Tanguy*. New York: Museum of Modern Art, 1955, p. 20.

1956

Smith, Henry Homes, et. al. 'Frederick Sommer: Collages of Found Objects / Six Photographs with Reactions by Several People.' *Aperture* 4:3, 1956, pp. 103–117.

1957

'He Builds Pictures: This Prescott Photographer Seeks the Unusual to Create "Imaginative, Speculative" Pictures.' *Arizona Days and Ways Magazine*, May 5, 1957, pp. 6–7.

White, Minor, ed. 'An Experiment in Reading Photographs.' *Aperture* 5:2, 1957, pp. 51–75.

1958

Layton, Irving. *A Laughter in the Mind*. Highlands, North Carolina: Jonathan Williams, 1958.

1959

'New Talent.' *Art in America*. Vol. 47, No. 1, Spring, 1959, pp. 81, 84.

1960

Gruber, L. Fritz, ed. *Famous Portraits*. New York: Ziff-Davis, 1960, pp. 149, 159, plate #97.

'New Talent.' *Art in America*, Vol. 48, No. 1, Spring, 1960, pp. 38–47.

Olson, Charles. *The Maximus Poems*. New York: Jargon Books/ Corinth Books, 1960.

White, Minor, ed. 'The Sense of Abstraction in Contemporary Photography.' *Aperture* 8:2, 1960, pp. 72–117.

1961

'Letters to the Editor.' *Aperture* 9:4, 1961, pp. 175–176.

'New Talent.' *Art in America*, Vol. 49, No. 1, Spring, 1961, pp. 52-57.

'Twentieth Century American Art.' A special issue of the *Kalamazoo Institute of Arts Bulletin*, No. 3, September, 1961, n.p.

Williams, Jonathan. 'The Eyes of Three Phantasts: Laughlin, Sommer, Bullock.' *Aperture* 9:3, 1961, pp. 96–123.

1962

'New Talent.' *Art in America*, Vol. 50, No. 1, 1962, pp. 44–51.

White, Minor, ed. *Frederick Sommer, 1939–1962: Photographs*. Aperture 10:4, 1962.

1963

Heath, David. Review of *Aperture* 10:4, *Frederick Sommer, 1939–1962: Photographs*. *Contemporary Photographer*. Summer, 1963.

1964

Photography 64/ An Invitational Exhibition. Rochester, New York: State Exposition and the George Eastman House, 1964, pp. 29, 44.

1965

Doty, Robert M., ed. *Photography in America: 1850–1965*. New Haven, Connecticut: Yale University Art Gallery, 1965.

Millard, Charles W. III. 'Frederick Sommer: Exhibition of Work from 1943–1956.' *Contemporary Photographer*, Vol. 5, No. 3, 1965, pp. 70–72.

Nordland, Gerald. *Frederick Sommer: An Exhibition of Photographs*. Washington, D.C.: Washington Gallery of Modern Art, February, 1965.

1967

Lyons, Nathan. *Photography in the Twentieth Century*. New York: Horizon Press in collaboration with the George Eastman House, 1967, p. 53.

Six Photographers. Urbana, Illinois: University of Illinois, College of Fine and Applied Arts, 1967.

Smith, Henry Holmes. 'Photography in Our Time: A Note on Some Prospects for the Seventh Decade.' *Kalamazoo Arts Center Bulletin*, No. 2, 1967.

'Sommer Photography Shown.' *Arizona Daily Sun* [Flagstaff], June 1, 1967.

Three Photographers: Wynn Bullock, Edmund Teske, Frederick Sommer. Northridge, California: San Fernando Valley State College, 1967.

White, Minor, ed. *Aperture* 13:3, 1967.

1968

The Music of Frederick Sommer. Prescott, Arizona: Prescott College, May 8, 1968.

Nordland, Gerald. *Frederick Sommer: An Exhibition of Photographs*. Philadelphia: Philadelphia College of Art, 1968.

Stevens, A. Wilbur. 'The Arts in Focus.' *The Prescott Courier*, May 9, 1968, p. 5.

1969

Doty, Robert M. *Human Concern/Personal Torment: The Grotesque in American Art*. New York: Whitney Museum of American Art, 1969.

Mann, Margery. 'Frederick Sommer.' *Popular Photography*, Vol. 65, No. 4, October, 1969, pp. 82–83, 133–134.

The Persistence of Beauty: Portfolio One. Carmel: The Friends of Photography, 1969.

Photographs from the Coke Collection. Albuquerque, New Mexico: Museum of Albuquerque, 1969.

1970

Albright, Thomas. 'Concern and Torment at the U.C. Galleries.' *San Francisco Examiner-Chronicle, This World*, February 1, 1970.

1971

Braun, Richard Emil. *Bad Land*. Penland, North Carolina: The Jargon Society, Penland School, 1971.

Sommer, Frederick. 'An Extemporaneous Talk at the Art Institute of Chicago, October, 1970.' *Aperture* 16:2, 1971.

1972

Gassan, Arnold. *A Chronology of Photography: A Critical Survey of the History of Photography as a Medium of Art*. Athens, Ohio: Handbook Company, 1972, pp. 123–124, 189, 196–197, plate #152.

Gollin, Jane. *Art News*, Vol. 71, No. 8, December, 1972, p. 13.

The History of Photography Calendar 1973. New York: Light Gallery, 1972.

Photographien 1900–1970. Saamlung L. Fritz Gruber. Köln: Kolnischer Kunstverein, 1972.

Sommer, Frederick, in collaboration with Stephen Aldrich. *The Poetic Logic of Art and Aesthetics*. Prescott, Arizona, 1972.

Thornton, Gene. 'The Early Sommer Was More Original.' *The New York Times*, October 15, 1972, Section II, p. 34.

Wasserman, C.R. 'Fogg Show Traces U.S. Imagery.' *Boston Globe*, May 7, 1972.

1973

Boice, Bruce. 'Frederick Sommer.' *Artforum*, Vol. 11, No. 5, January, 1973, p. 86.

Bulletin of the University of New Mexico University Art Museum, Vols. 5–6 (1971–72).

Case, William D. *Arts Magazine*, Vol. 47, No. 3, December–January, 1973, pp. 84–85.

The History of Photography Calendar 1974. New York: Light Gallery, 1973.

Kelly, Jain. 'Frederick Sommer.' *Art in America*, Vol. 61, No. 1, January–February, 1973, pp. 92–94.

Landscape and Discovery: An Exhibition of Photography. Hofstra University: Hempstead, New York, 1973.

Mann, Margery. 'Sommertime.' *Camera 35*, Vol. 17, No. 2, March, 1973, pp. 28–29, 71–72.

Schwartz, Sanford. 'New York Letter.' *Art International*, Vol. 17, No. 1, January, 1973, pp. 71–72.

Szarkowski, John. *Looking at Photographs: 100 Pictures from the Collection of the Museum of Modern Art*. New York; Museum of Modern Art, 1973, pp. 162–163.

Werner, Donald L., ed. *Light and Lens: Methods of Photography.* Yonkers, New York: Hudson River Museum, 1973, pp. 42–43.

1974

Doty, Robert M., ed. *Photography in America 1850–1965.* New York: Random House, A Ridge Press Book, 1974. (Published for the Whitney Museum of American Art.)

On Time: 1975 Appointment Calendar. New York: Museum of Modern Art, 1974.

1975

Craven, George M. *Object and Image: An Introduction to Photography.* Englewood Cliffs, New Jersey: Prentice-Hall, Inc., 1975, p. 182.

'Max Ernst.' *Connaissance des Arts*, No. 280, June, 1975, pp. 78–88.

Thornton, Gene. 'New Focus on an Old Idea.' *The New York Times*, September 14, 1975, Section II, p. 31.

1976

Catalogue of the UCLA Collection of Contemporary American Photographs. Los Angeles: University of California at Los Angeles, Frederick S. Wright Art Gallery, 1976, pp. 54–55.

Contemporary Photographs. New York: Light Gallery, 1976.

Emmet Gowin: Photographs. New York: Alfred A. Knopf, A Light Gallery Book, 1976.

Exposure 14:2, May, 1976, p. 35.

'Frederick Sommer.' *Special Report 1976.* Tucson: Center for Creative Photography, 1976, pp. 23–25.

McCabe, Cynthia Jaffe, ed. *The Golden Door: Artist Immigrants of America, 1876–1976.* Washington, D.C.: Smithsonian Institution Press, 1976, pp. 245–249.

Nordgren, Sune, ed. 'Frederick Sommer.' *kalejdoskop* 6:76, 1976.

Photographic Process as Medium. New Brunswick, New Jersey: Rutgers University Art Museum, 1976, p. 31.

Tucker, Anne, ed. *The Target Collection of American Photography.* Houston: Museum of Fine Arts, 1976, p. 9.

Weideger, Paula. *Menstruation and Menopause: The Physiology and Psychology, the Myth and the Reality.* New York: Alfred A. Knopf, January, 1976.

1977

Enyeart, James. *Bruguière: His Photographs and His Life.* New York: Alfred A. Knopf, 1977, pp. 142–143.

'A Frederick Sommer Portfolio.' *Exposure* 15:1, February, 1977, pp. 4–7.

Hellman, Roberta and Marvin Hoshino. 'Frederick Sommer.' *Arts Magazine*, Vol. 51, No. 10, June, 1977, p. 23.

1978

Art Journal, Vol. 37, No. 4, Summer, 1978, p. 318.

'A Conversation Between Aaron Siskind and Diana Johnson.' *Bulletin of Rhode Island School of Design*, Vol. 64, No. 4, April, 1978.

Clisby, Roger. D. *Forty American Photographers.* Sacramento, California: E. B. Crocker Art Gallery, 1978, p. 12.

1979

Approaches to Photography: A Historical Survey. Amarillo, Texas: Amarillo Art Center, 1979, p. 13.

Green, Jonathan. '*Aperture* in the 50's: The Word and the Way.' *Afterimage*, Vol. 6, No. 8, March, 1979, pp. 8–13.

Lifson, Ben. 'Sommer: I Shew You a Mystery.' *The Village Voice*, October 8, 1979, p. 111.

Sommer, Frederick. 'An Extemporaneous Talk at the Art Institute of Chicago, October, 1970,' *The Camera Viewed: Writings on Twentieth Century Photography.* New York: E. P. Dutton, 1979, pp. 55–70.

1980

Glenn, Constance W. and Bledsoe, Jane K., eds. *Frederick Sommer at Seventy-Five.* Long Beach, California: The Art Museum and Galleries, California State University, 1980.

VENUS, JUPITER & MARS— *The Photographs of Frederick Sommer,* has been designed by Katy Homans. The type, Monotype Bembo and Centaur, was set by Michael & Winifred Bixler, and the negatives for the photographs were made in 300-line screen duotone by Richard Benson. The catalogue was printed on Warren's Lustro Offset Enamel by The Meriden Gravure Company. The binding is by Robert Burlen & Son.

The exhibition and catalogue were conceived and developed by John Weiss.

EXHIBITION CHECKLIST

A Supplement to

Venus, Jupiter & Mars

The Photographs of Frederick Sommer

An Exhibition at the Delaware Art Museum
Cosponsored by the Department of Art, University of Delaware
April 27—June 8, 1980

This *Exhibition Checklist* provides a visual record of the photographs of Frederick Sommer exhibited at the Delaware Art Museum from April 27 through June 8, 1980. It is published as an aid to both gallery visitors and historians concerned with identifying a major portion of Sommer's opus—much of it previously hidden from view.

Photographs are labeled by confirmed title only. However, many of Sommer's untitled photographs have acquired adopted names and are so identified within parentheses. All dimensions are in inches, height preceeding width.

The exhibition and catalogue that accompanies it, V E N U S, J U P I T E R & M A R S— *The Photographs of Frederick Sommer,* are cosponsored by the Department of Art, University of Delaware, and the Delaware Art Museum. Catalogues may be ordered by mail through the Delaware Art Museum, Museum Shop, 2301 Kentmere Parkway, Wilmington, Delaware, 19806.

Our lenders to the exhibition, named and anonymous, are gratefully acknowledged. Funding for this project was made possible by the generous support of the Ford Motor Company Fund; Container Corporation of America; Light Gallery, New York City; the Delaware Art Museum; the Department of Art, University of Delaware; Mr. Aldo Romagnoli, proprietor of the Newark Camera Shop, Newark, Delaware; by two grant awards from the Delaware State Arts Council, a state agency, and the National Endowment for the Arts, a federal agency; and by several anonymous donations.

Copy prints for the *Exhibition Checklist* were prepared under the direction of Charles Metzger. It was designed by Katy Homans and printed by Mercantile Printing Company, Inc.

JOHN WEISS

Guest Curator
Associate Professor of Art
University of Delaware

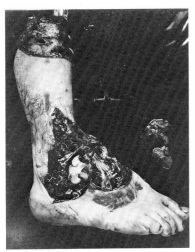

1. *Untitled* (Amputated Foot)
1939 9½ x 7⅝
Courtesy of the Fogg Art Museum, Harvard
University

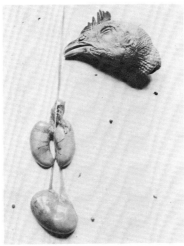

3. *Untitled*
1939 9½ x 7⅝
Private Collection

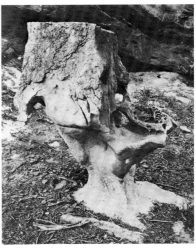

6. *Untitled*
1940 9½ x 7⁹⁄₁₆
Courtesy of The Museum of Modern Art, New York

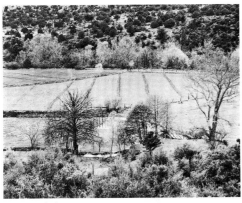

2. *Untitled*
1939 7⁹⁄₁₆ x 9½
Private Collection

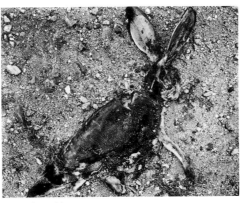

4. *Jack Rabbit*
1939 7½ x 9½
Courtesy of David P. Becker

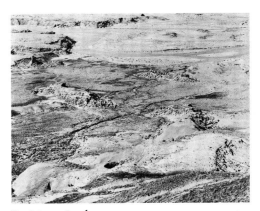

7. *Arizona Landscape*
1941 7½ x 9½
Private Collection

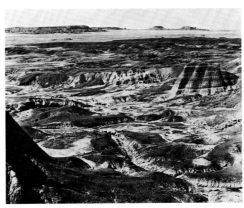

5. *Petrified Forest National Monument*
1940 7⅝ x 9½
Courtesy of The Museum of Modern Art,
New York

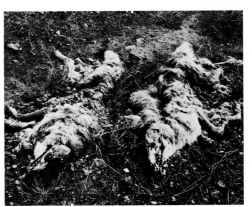

8. *Coyotes*
1941 7½ x 9½
Courtesy of The Art Museum, Princeton
University

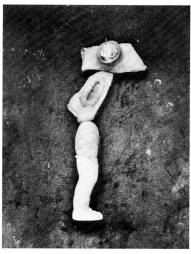

9. *Untitled* (Leg with Chicken Asshole)
1941 9½ x 7⁹⁄₁₆
Courtesy of the Indiana University Art Museum

10. *Arizona Landscape*
1943 7⅝ x 9½
Courtesy of David P. Becker

11. *Arizona Landscape*
1943 7⅝ x 9½
Courtesy of the Fogg Art Museum, Harvard University

12. *Arizona Landscape*
1943 7⅝ x 9½
Courtesy of Dr. and Mrs. Gene Gary Gruver

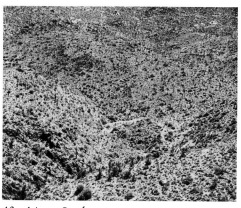

13. *Arizona Landscape*
1943 7½ x 9⅜
Courtesy of Marc and Diana Harrison

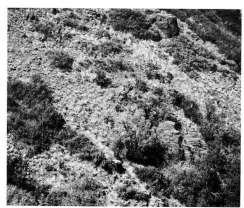

14. *Arizona Landscape*
1943 7⅝ x 9½
Courtesy of The Museum of Modern Art, New York

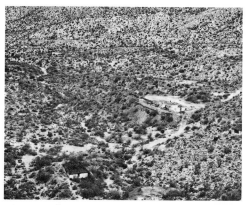

15. *Constellation—Arizona*
1943 7⅝ x 9½
Private Collection

16. *Dugas, Arizona*
1943 7⁹⁄₁₆ x 9½
Courtesy of The Arizona Bank, Phoenix, Arizona

17. *Frances*
1943 9½ x 7½
Private Collection

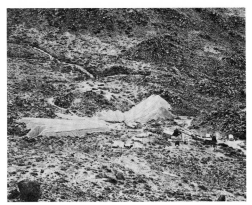

18. *Goldmine—Arizona*
 1943 7⅝ x 9½
 Courtesy of David P. Becker

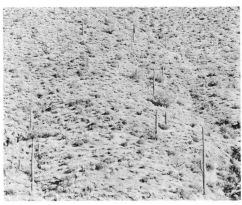

21. *Arizona Landscape*
 1945 7⁹⁄₁₆ x 9½
 Courtesy of Dr. and Mrs. Gene Gary Gruver

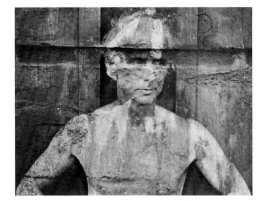

24. *Max Ernst*
 1946 7⁹⁄₁₆ x 9½
 Private Collection

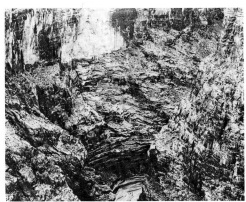

19. *Little Colorado River*
 1943 7⅝ x 9½
 Private Collection

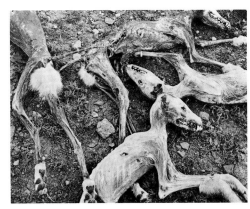

22. *Coyotes*
 1945 7⅝ x 9½
 Courtesy of Jonathan Williams

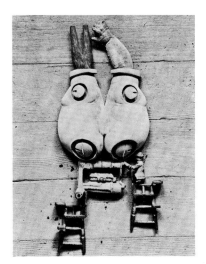

25. *The Giant*
 1946 9⁷⁄₁₆ x 7⅜
 Courtesy of the Crocker Art Museum,
 Sacramento, California

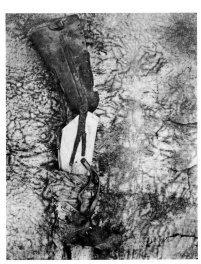

20. *Artificial Leg*
 1944 9½ x 7⅝
 Courtesy of The University of Nebraska- Lincoln

23. *Taylor, Arizona*
 1945 7⅝ x 9½
 Courtesy of Marc and Diana Harrison

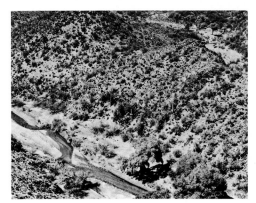

26. *Arizona Landscape*
 1947 7⅝ x 9½
 Private Collection

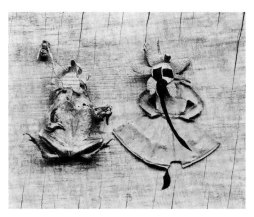

27. *Flower and Frog*
1947 7⅝ x 9½
Private Collection

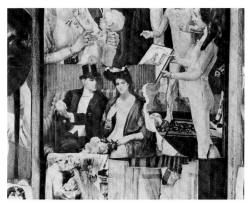

28. *I Adore You*
1947 7⅝ x 9½
Private Collection

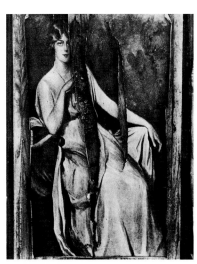

29. *Orminda*
1947 9½ x 7½
Courtesy of Susan Harder

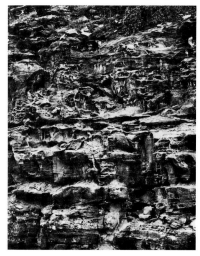

30. *Untitled*
1947 9⁹⁄₁₆ x 7⅝
Courtesy of David P. Becker

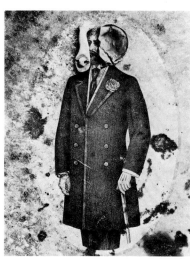

31. *Untitled*
1947 9½ x 7⅝
Courtesy of Evelyn and Francis Coutellier

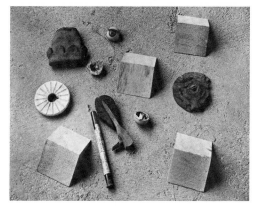

32. *Untitled*
1947 7½ x 9½
Private Collection

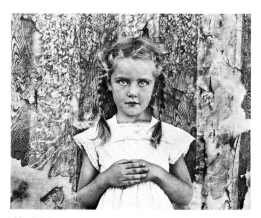

33. *Livia*
1948 7⅝ x 9½
Private Collection

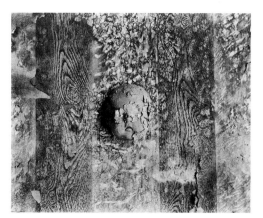

34. *Medallion*
1948 7⅝ x 9½
Courtesy of The Museum of Modern Art,
New York

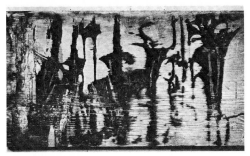

35. *Found Painting*
1949 5 x 9½
Courtesy of the Robert Freidus Gallery,
New York

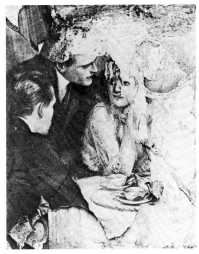

38. *Venus, Jupiter & Mars*
1949 9½ x 7⅝
Private Collection

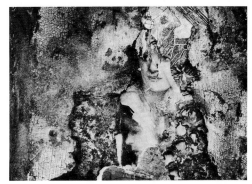

40. *Circumnavigation of the Blood*
1950 4¹/₁₆ x 5⅝
Courtesy of Marc and Diana Harrison

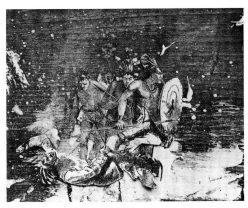

36. *The Milky Way*
1949 7⅝ x 9½
Courtesy of Marc and Diana Harrison

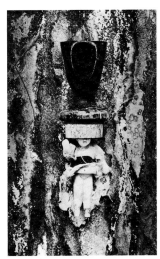

39. *All Children Are Ambassadors*
1950 6⅛ x 3¾
Courtesy of Jonathan Williams

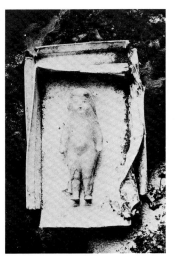

41. *The Eatable Thief*
1950 5⅜ x 3⁹/₁₆
Courtesy of The Museum of Modern Art,
New York

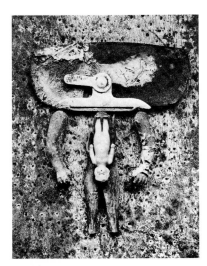

37. *Valise d'Adam*
1949 9⅛ x 7¼
Courtesy of Peter C. Bunnell

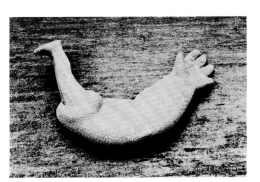

42. *Ondine*
1950 3¹¹/₁₆ x 5½
Courtesy of The Museum of Modern Art,
New York

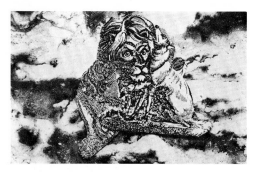

43. *The Pontine Marshes*
1950 3½ x 5⅝
Courtesy of The University of New Mexico

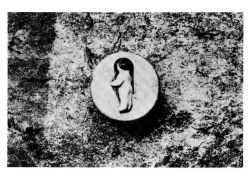

44. *Return of the Prodigal*
1950 3¾ x 5¹¹⁄₁₆
Courtesy of The Museum of Modern Art,
New York

45. *Untitled*
1950 9½ x 7½
Private Collection

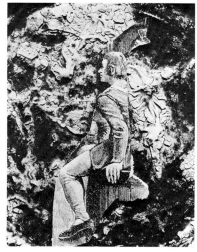

46. *Idée et Orchidée*
1951 9½ x 7½
Private Collection

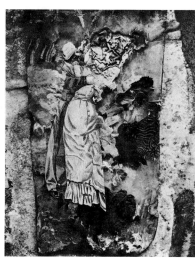

47. *Moon Culmination*
1951 9⁹⁄₁₆ x 7⅝
Courtesy of The Museum of Modern Art,
New York

48. *Sumaré*
1951 7⅝ x 9½
Courtesy of The Museum of Modern Art,
New York

49. *The Wall*
1951 9⅝ x 7⅝
Courtesy of the Minor White Archive,
Princeton University

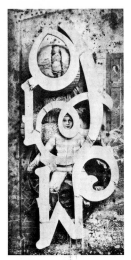

50. *Young Explorer*
1951 8¾ x 4¼
Private Collection

53. *Mexican Bather*
1952 9⅝ x 7⅝
Courtesy of the Minor White Archive,
Princeton University

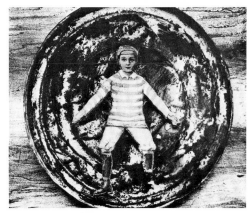

56. *Young Explorer II*
1954 7⅝ x 9½
Private Collection

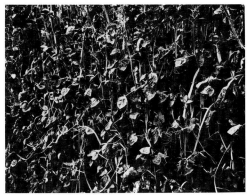

51. *Untitled* (Weeds)
1951 7⅝ x 9½
Courtesy of Jonathan Williams

54. *Nogales, Mexico*
1952 7⅞ x 11¾
Courtesy of Light Gallery, New York

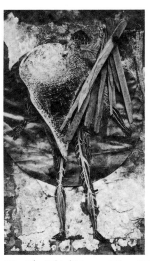

57. *The Thief Greater Than His Loot*
1955 8 x 5 (irregular)
Courtesy of Dr. and Mrs. Grover Austin

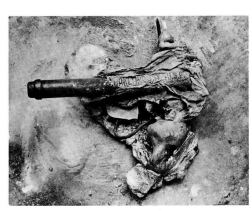

52. *Fighting Centaur*
1952 7⅝ x 9½
Courtesy of the Robert Freidus Gallery,
New York

55. *Mazatlan*
1954 7¾ x 11¾
Courtesy of the Museum of Art,
Rhode Island School of Design

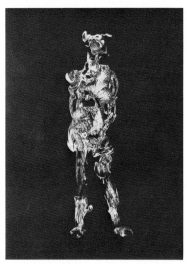

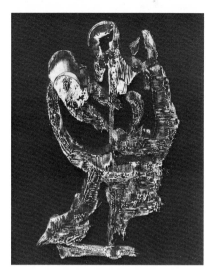

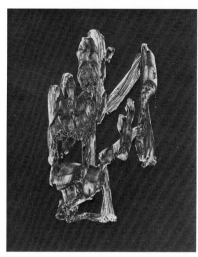

58. *Untitled* (Configurations on Black #3)
1957 17⅜ x 12⅛
Courtesy of The Museum of Modern Art,
New York

60. *Untitled* (Drawing Enlarged)
1957 13⁵⁄₁₆ x 10⅜
Courtesy of the Indiana University Art
Museum

62. *Untitled* (Paint on Cellophane)
1957 13¼ x 10⅜
Courtesy of the Indiana University Art
Museum

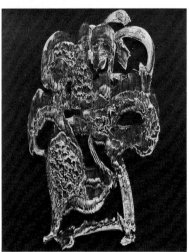

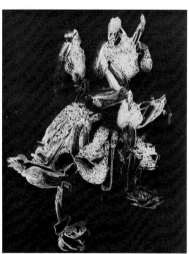

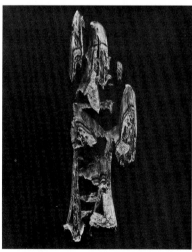

59. *Untitled* (Configurations on Black #8)
1957 13⁵⁄₁₆ x 10⅜
Courtesy of The Museum of Modern Art,
New York

61. *Untitled* (Paint on Cellophane)
1957 13⁵⁄₁₆ x 10½
Courtesy of The Dayton Art Institute

63. *Untitled* (Paint on Cellophane)
1957 19⅜ x 15½
Private Collection

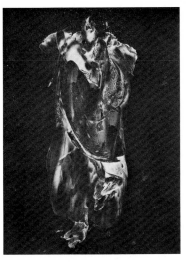

64. *Paracelsus*
1959 13⅝₆ x 10¼
Courtesy of Gerald Nordland

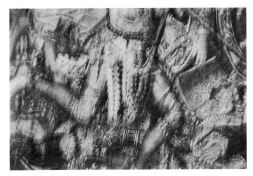

66. *Victoria and Albert Museum*
1959 8 x 11¾
Private Collection

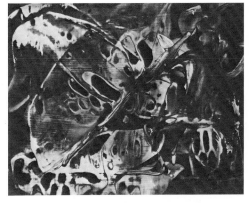

69. *Untitled* (Smoke on Cellophane #1)
1961 10½ x 13¼
Courtesy of Marc and Diana Harrison

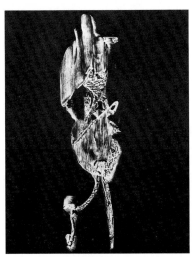

65. *Stendhal*
1959 13⅜ x 10⅝
Courtesy of the International Museum of
Photography at George Eastman House

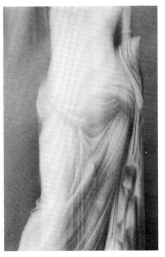

67. *Capitoline Museum*
1960 11¼ x 7½
Courtesy of Marc and Diana Harrison

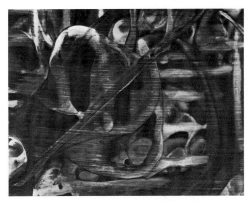

70. *Untitled* (Smoke on Cellophane #3)
1961 10¼ x 13⅛
Courtesy of The Museum of Modern Art,
New York

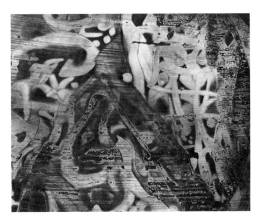

68. *The Golden Apples* (Smoke on Cellophane #5)
1961 10⁷⁄₁₆ x 13¼
Courtesy of Marc and Diana Harrison

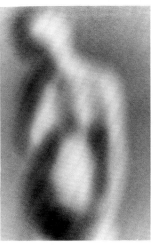

71. *Untitled*
1961 13¼ x 8½
Courtesy of Marc and Diana Harrison

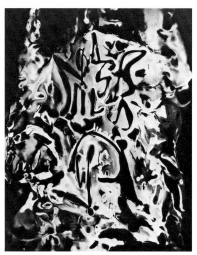

72. *Smoke on Glass*
1962 13¼ x 10⅜
Courtesy of the Indiana University Art
Museum

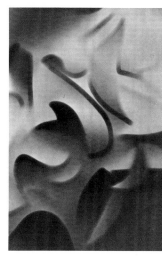

74. *Cut Paper*
1963 13⁵⁄₁₆ x 8¾
Courtesy of The Museum of Modern Art,
New York

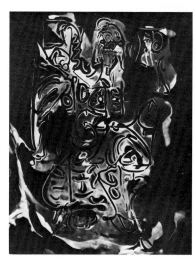

76. *Smoke on Glass*
1963 13¼ x 10
Courtesy of the Museum of Fine Arts,
St. Petersburg, Florida

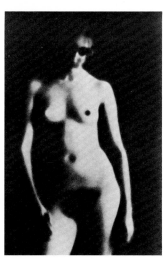

73. *Untitled*
1962 13¼ x 8¾
Courtesy of The Museum of Modern Art,
New York

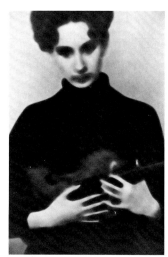

75. *Lee Nevin*
1963 13¼ x 8⅞
Courtesy of the Indiana University Art
Museum

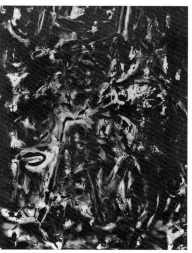

77. *Heraclitus*
1964 13⅜ x 10⅜
Courtesy of Jonathan Williams

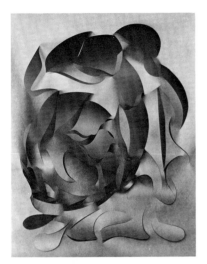

78. *Cut Paper*
1965 13¼ x 10½
Courtesy of the Museum of Fine Arts,
St. Petersburg, Florida

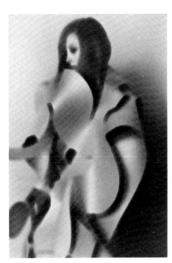

80. *Figure in Cut Paper*
1965 13¼ x 8⅞
Private Collection

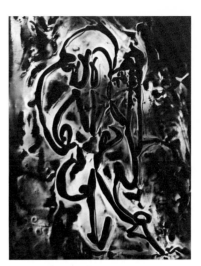

82. *Smoke on Glass*
1965 13⅜ x 10½
Courtesy of The University of Nebraska-
Lincoln

79. *Emerson Woelffer*
1965 13 x 8¾
Courtesy of Mr. and Mrs. Emerson Woelffer

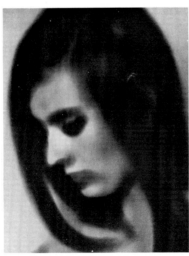

81. *Lee Nevin*
1965 13¼ x 10⁷⁄₁₆
Courtesy of the Krannert Art Museum,
University of Illinois at Urbana-Champaign

83. *Untitled* (Lee Nevin)
1965 13⁵⁄₁₆ x 8¾
Courtesy of The Dayton Art Institute

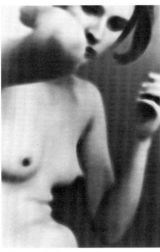

84. *Untitled*
1965 13⁵⁄₁₆ x 8¾
Courtesy of the Indiana University Art
Museum

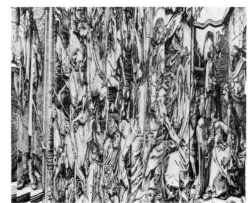

86. *Dürer Variation No. 1*
1966 7⁹⁄₁₆ x 9⅜
Courtesy of Ingrid and Charles Semonsky

88. *Cut Paper*
1967 13 x 10⅛
Courtesy of The Dayton Art Institute

85. *Untitled*
1965 13¼ x 8¾
Courtesy of Mr. and Mrs. Stephen White

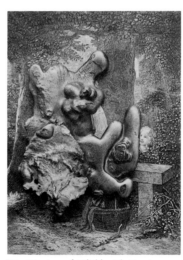

87. *Virgin and Child with St. Anne and the Infant
St. John*
1966 9⁷⁄₁₆ x 7¹⁄₁₆
Courtesy of The Dayton Art Institute

89. *Cut Paper*
1967 13¼ x 10½
Courtesy of the Indiana University Art
Museum

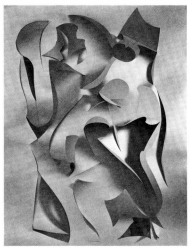

90. *Cut Paper*
 1967 10½ x 8¼
 Private Collection

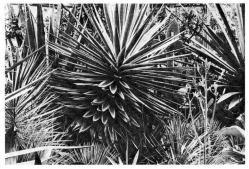

91. *Kyoto Botanical Garden*
 1969 8¼ x 12⅛
 Private Collection

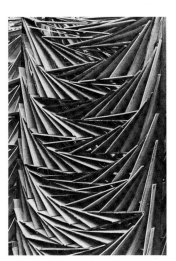

92. *Kyoto Lumber Yard*
 1969 12¼ x 8¼
 Private Collection

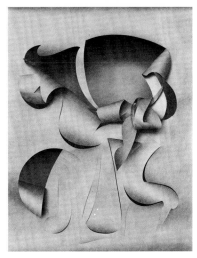

93. *Cut Paper*
 1972 11 x 8⅜
 Private Collection

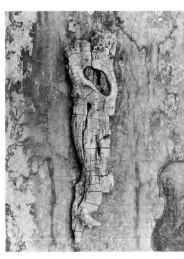

94. *Untitled* (Wood and Violin)
 1973 13 x 10⅜
 Courtesy of the Sun Valley Center for the
 Arts and Humanities

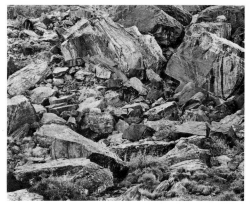

95. *Untitled*
 1973 7⅝ x 9½
 Courtesy of Lucinda W. Bunnen

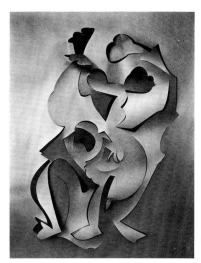

96. *Cut Paper*
 1977 9⁹⁄₁₆ x 7½
 Courtesy of Ingrid and Charles Semonsky

97. *Judgement of Solomon*
N.D. 9½ x 7⅝
Courtesy of Jonathan Williams

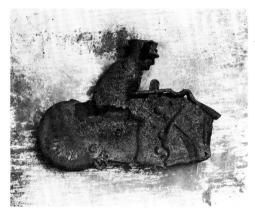

99. *Untitled* (Rusted Toy Motorcyclist)
N.D. 7⅝ x 9⁹⁄₁₆
Courtesy of the Indiana University Art
Museum

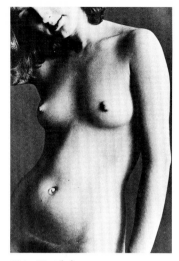

101. *Untitled*
N.D. 10⅜ x 6⅞
Courtesy of the Indiana University Art
Museum

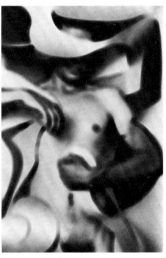

98. *Untitled* (Figure in Cut Paper)
N.D. 13¼ x 8¾
Courtesy of the Museum of Art,
Rhode Island School of Design

100. *Untitled*
N.D. 7⅝ x 9½
Courtesy of the Indiana University Art
Museum

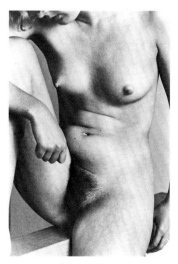

102. *Untitled*
N.D. 11¾ x 7¾
Courtesy of Dr. Samuel H. Lerner